BASICS OF DRAWING
The Ultimate Guide for Beginners

LEONARDO PEREZNIETO

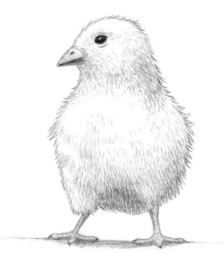

BASICS OF DRAWING
The Ultimate Guide for Beginners

LEONARDO PEREZNIETO

Get Creative 6

New York

Get Creative 6

An imprint of Mixed Media Resources
19 West 21st Street,
Suite 601
New York, NY 10010
sixthandspringbooks.com

EDITOR
Pamela Wissman

ART DIRECTOR
Irene Ledwith

CHIEF EXECUTIVE OFFICER
Caroline Kilmer

PRESIDENT
Art Joinnides

CHAIRMAN
Jay Stein

Library of Congress Cataloging-in-Publication Data
Pereznieto, Leonardo, 1969- author.
Basics of drawing : the ultimate guide for beginners /
Leonardo Pereznieto.
First edition. | New York, New York : Get Creative 6, [2020] |
 Includes index.
LCCN 2020018527 | ISBN 9781684620166 (paperback)
LCSH: Drawing--Technique.
LCC NC730 .P474 2020 | DDC 741.2--dc23

5 7 9 10 8 6

First Edition

Printed in China

Introduction

Drawing is a gratifying act that can soothe, calm, and bring joy to our hearts. Those who are passionate about drawing find fulfillment in it, and people admire those who are proficient at it.

A drawing can be a rapid sketch or a work of art all by itself. Drawing is also the foundation for the rest of the visual arts, including painting, design, architecture, sculpture, and more. It's a skill worth having, and I wrote this book to help you do it well.

They say, "Practice makes perfect," which is generally true, but the practice needs to be done correctly. If you were to practice a mistake over and over, you would only become proficient at making that mistake. You must learn the basic techniques correctly. Then, with practice, you can become a master.

Many art schools have lost sight of these essentials, resulting in graduates getting diplomas in fine arts without being able to draw. As they then become the professors of a new generation, these new teachers are incapable of adequate instruction. For the students, it has become harder and harder to learn.

Many art instructors around the world use my short drawing tutorials on YouTube to teach their students how to draw, to show them the right techniques. When I became aware of this, I decided to write this book, to assist both teachers to teach, and students to learn. Once you have the basics, with practice, you can unleash your imagination, and create whatever you like. It doesn't matter what your age is; if you learn the right techniques and practice applying them, you will get results. Don't be discouraged if you don't get the results you want immediately, or even after a few attempts. If you apply yourself and work hard at it, you will get it.

Finally, since about half of the skill of an artist resides in being able to observe in a certain way, as well as on the ability to simplify concepts, it very well may be that this book not only teaches you the basics of drawing, but that it even changes the way you look at the world!

How to Use This Book

To get the most out of this book, I recommend you read it in sequence, look at the pictures as you read, and do the exercises as they are presented, since most of them build on prior concepts. The way to learn to draw is to do it actively. How much you get out of this book depends on how much you put into it. The number of hours of study and practice will determine how much progress you make.

Most of the exercises are meant to be done over and over. The more you do them, the better your skills will become. After completing an exercise to the point where you feel proficient with it, continue with the book. However, I recommend you come back to the exercises over and over again, because the better you become, the higher your standards will be for your results. These exercises will always help you improve, and I want this book to be in your studio, worn out by use, stained with graphite and charcoal, with the pages bent. I want you to use it as a reference again and again. Sad is the fate of a book that is kept prisoner on a shelf.

While reading this book, it is also critical that you don't pass by a word that you don't understand. Undefined words can make the subject seem confusing, and it may even affect your performance, but once you have a clear concept of the meaning of the word, everything should become easy again. To help you with this, I have included a glossary of terms related to drawing. If you find that you don't understand a word that is not in the glossary, use a regular dictionary to clear it up.

If at any point you're not getting the results you want, and you're losing confidence in yourself, don't. I'm confident that following these techniques, with practice, you will achieve the intended result. Don't ever lose hope or faith in yourself. I'm here with you, through this book, to help you work things out, and to make sure that drawing becomes a joy, as it should be.

Table of Contents

CHAPTER 1
Drawing Materials

Creating a masterpiece with raw materials on a flat surface is the magic of art. Basic drawing materials are reasonably inexpensive—you can get excellent results with very little cost. Begin with the basics, and expand as you progress. Knowing the properties of various materials will be helpful, and it will show in your work.

Graphite Pencils

The most popular drawing tools are graphite pencils. They are precise and versatile. They can be used for both sketches and detailed drawings. The lead is a mix of graphite powder and a binder (clay, wax, etc.) that holds it together. The more binder in the mix, the harder the pencil is. The more graphite, the darker a mark it leaves.

Pencils have grades according to the hardness of the lead that appear as numbers and letters. H is commonly interpreted as hard, while B is for black. The higher the number, the harder or blacker the lead.

For a light touch, you might use H pencils (4H being harder than H) that stay sharp longer than B pencils. Use B pencils (6B being blacker than B), when going for a more expressive, dynamic mark, or when you need a darker area.

In the middle of hard and soft leads is HB (hard black), equivalent to the standard American number 2 pencil. Between H and HB, there is an additional one, F, which stands for firm. It is firmer than HB, but not as hard as H.

Lead Hardness and Softness
H = Hard The higher the number, the harder the lead
B = Black The higher the number, the softer the lead

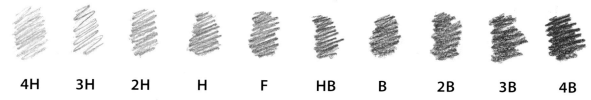

| 4H | 3H | 2H | H | F | HB | B | 2B | 3B | 4B |

The range of lead from hardest to softest (or blackest) is shown here from 4H (hardest on this scale) to 4B (softest or blackest on this scale, but pencils can go blacker).

Pencil Starter Set
A good starter set is 2H, HB, 3B, and 6B, then expand from there. However, a 2B from one manufacturer might be harder than a 2B from another, so purchase pencils or leads from the same brand to start with.

What should you start with, let's say, for sketching? Generally, start with HB. Then, once you try different pencils, you may find that you prefer something else.

Lead Holders

Lead holders combine the convenience of mechanical pencils (see below) with the qualities of wood pencils. You can buy bare lead at any art supplier, then insert it into a holder, where it's held in place. Just push a button to release the length (being careful that gravity doesn't cause the whole lead to fall out of the holder).

You can get different grades of leads for these holders, the same as for wooden graphite pencils. They come in various calibers (thicknesses), but the most common for general drawing is the 2mm lead, which is the same caliber as in wooden pencils.

Are lead holders or pencils better? Some artists prefer one, some the other. I have a set of holders in different colors, and I keep the same leads in the same colors. I always have a 2H in the gray holder, HB in black, 3B in red, and 6B in yellow. I can pick the right one at a glance. I also love thicker lead holders, for a core of 5.4mm. They're great for bold, rapid sketching, and to fill in larger areas quickly.

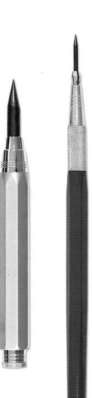

Lead Holders

Mechanical Pencils

Mechanical pencils are similar to lead holders, but for smaller-caliber (thinner) leads. The smallest is .3mm, then .5mm, .7mm, and .9mm. The range of softness to hardness is less extensive than wood pencils and lead holders, usually 4H (hardest) to 2B (softest). Mechanical pencils have a more elaborate push mechanism to advance the lead in increments, preventing it from dropping out.

The advantage of mechanical pencils is that the leads are so thin, you don't have to sharpen them. However, sometimes the tip flattens when drawing, perhaps more than you may like for minute details. When this happens, rotate the holder slightly (therefore the tip) to avoid using the flattened surface. Keep turning it every so often while drawing, so that the point stays "sharp."

One limitation of mechanical pencils is that if you want to sketch almost parallel to the paper (holding the pencil almost sideways), the casing may get in your way. Also, since the lead doesn't come in very soft grades, you must use another type of pencil for intense darks. You may be better off using a thicker lead if you need to fill a large area.

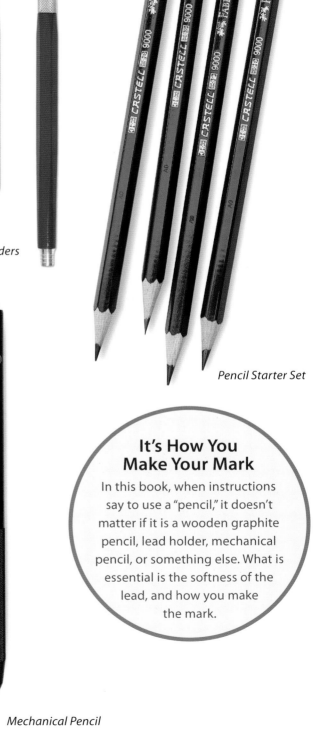

Pencil Starter Set

It's How You Make Your Mark

In this book, when instructions say to use a "pencil," it doesn't matter if it is a wooden graphite pencil, lead holder, mechanical pencil, or something else. What is essential is the softness of the lead, and how you make the mark.

Mechanical Pencil

Graphite Sticks

Compressed graphite can also be made into rectangular or square sticks. These are very helpful when you need to shade larger areas, since the sides leave broad marks for different effects. However, the corners can also be used for more delicate lines.

 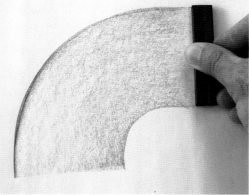

Graphite Sticks

Graphite and Charcoal Powder

Graphite powder, as well as charcoal powder, can be purchased, but you can also produce it by rubbing the core of a pencil or a stick on sandpaper (or if you use lead holders you can save the leftover graphite from sharpening the leads). Both graphite and charcoal powder are handy for toning large areas by spreading them with a chamois, cotton cloth, or brush. After toning an area, one can easily get lights by lifting the powder off with a clean chamois or with a kneaded eraser.

 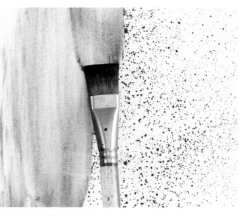

Graphite and Charcoal Powder *Spreading Charcoal Powder with a Brush*

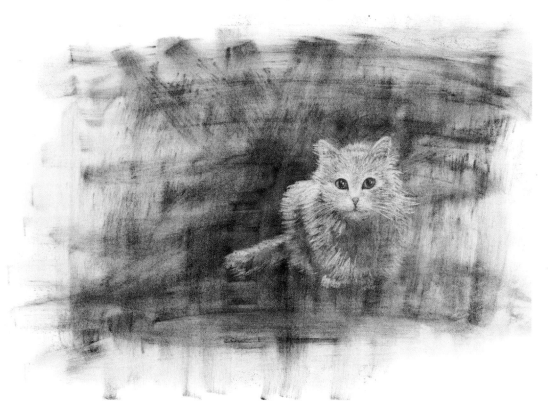

Charcoal Powder Drawing

Charcoal

The dark marks left by charcoal make it one of the boldest materials for drawing, excellent for sketching, as well as finished art. Charcoal for drawing is made by burning wood into charcoal powder, which is then mixed with a binder to form the drawing medium. It is then set inside a wood pencil or made into a stick.

Charcoal Pencils

Charcoal pencils generally range from 6B (softest) to HB (hardest). Graphite is great for details, but it will not give you blacks as deep as charcoal. Also, if you push graphite to get a very dark tone, it becomes shiny. If you need a deep black, use charcoal or carbon pencils (a combination of graphite and charcoal).

Carbon Pencils

Carbon pencils are made from a mixture of graphite and charcoal powder, compressed and held together with a binder. The feel is in between that of graphite and charcoal pencils, and carbon pencils do deliver nice blacks. They can be used together with graphite or charcoal, and are great to give some black accents to your graphite drawings.

Compressed Charcoal Sticks

Compressed charcoal sticks are made from charcoal powder mixed with a binder, then compressed into sticks. They are hard enough to be sharpened for more delicate lines, and their marks are darker and harder to erase than that of natural charcoal. They can be used at an angle, on the short end, flat on the paper, etc., depending on what kind of mark you want to get.

Compressed Charcoal Stick

Natural Charcoal Sticks

Charred willow or vine sticks are some of the oldest art materials in existence. They come in different calibers and softness. They're softer and more easily erasable than compressed charcoal, since they have no binders.

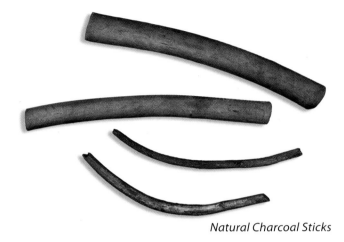

Natural Charcoal Sticks

"White Charcoal" Pencils

"White charcoal" is a misnomer, since these pencils are not charcoal. The core of white pencils is made from a natural white mineral called calcium carbonate. They are mainly used to draw highlights when working on toned paper. Of course, you can also make a whole drawing with white on toned paper if you like.

Finish with Fixative

Charcoal doesn't adhere well to a surface and smudges easily. Be sure to use a spray fixative on finished charcoal drawings to keep it in place.

Sanguine

Sanguine, or red chalk, is made of red-brown earth, and can be used for drawing in its natural form like the old masters did. However, today it's readily available in crayons or pencils. The term *sanguine* comes from the Latin word for blood, because of its reddish color.

You can use the side of a sanguine stick to cover large areas of a drawing, it can be sanded into a chisel shape, or sharpened into a point for detail, using a razor blade and medium-grit sandpaper (see Sharpening Tools). Sanguine is similar to pastel (next page), but slightly harder and drier. It can be blended smoothly for soft effects, or by adding water, it can be used for light washes, behaving more like watercolor. It is often applied to toned paper, and it can be combined with charcoal or sepia.

Sepia

Sepia pigment was originally taken from the ink of sea animals, such as squid. It is a dark brown color used mainly for monochromatic drawings (like sanguine). It is readily available in sticks and pencils. This color became famous all the way back in the Renaissance period, and it is still a favorite of artists, though today it's produced synthetically.

Fernando Pereznieto, sanguine, 8" x 6".

Pastels

Results achieved with pastels are often in between drawing and painting. Pastels can be used with long linear strokes or shorter strokes similar to brushstrokes. Generally, when portions of the paper are left without marks, it is called a drawing. When the whole support is filled in with pastels, it is called a painting.

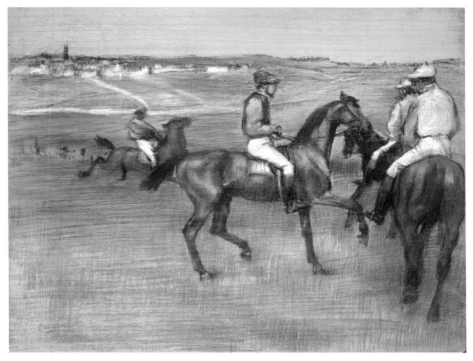

Edgar Degas, *Race Horses,* ca. 1885-88, dry pastel, The Metropolitan Museum of Art, New York City.

Dry Pastels

Dry pastels are like chalk, and come in a range of colors, as well as soft and hard. Soft pastels are the most commonly used, made with a high concentration of pigment and a bit of binder. Their marks are more vivid than hard pastels, making them great for layering and painterly effects. They are fragile though, and crumble easily. Hard pastels, which have more binder in them, are good for sketching and for more detailed work.

Pastel Pencils

Dry pastel can also be encased with wood and made into pencils, great for detailed and precise art. They have a similar feel to dry pastels, but are easier to use, and a lot cleaner, since you don't have to touch the pigment with your fingers. Some artists use them in combination with other pastels, especially for detailed work.

Oil Pastels

Oil pastels are sticks of pigment bound with an oil (or wax) medium, so they feel like crayons. They produce bright colors and don't smudge easily. You can apply them thickly, or thin them with a solvent (like turpentine) to paint thin washes.

They're not as good for blending as dry pastels, however, and can be more challenging to use. It's hard to get details with them, so they're often used for larger works, or for a rough, impressionistic finish. They're not compatible with dry pastels.

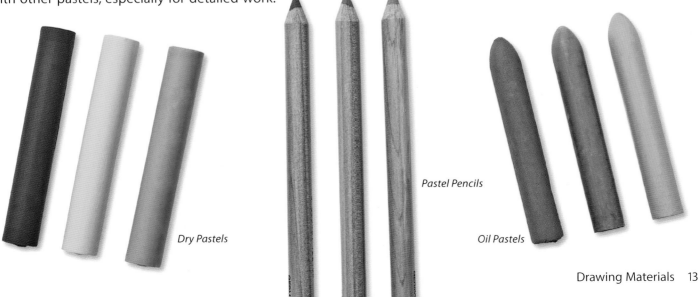

Dry Pastels

Pastel Pencils

Oil Pastels

Colored Pencils

Colored pencils are clean and great for delicate work. There are many good brands containing various proportions of pigments to binding agents. To combine colors, you can use a colorless "blender" that looks like a colored pencil but has no pigment. After you've layered colors, you can go over them with the colorless blender using a strong rubbing motion to mix them. This is called burnishing, which can intensify colors, giving them a lustrous look. You can also melt and mix the colors by applying mineral spirits to them.

Because of their oil or wax base, colored pencils are hard to erase. Use care when handling and storing colored pencils, because if they fall, the lead may crack internally, and then it's almost impossible to sharpen them, since they break on every attempt.

Erasable Colored Pencils

There are some colored pencils that, while they deliver less-vivid color, can be erased. They're great for sketching, since you can correct as needed, then draw over them with regular colored pencils later.

Colored Pencil Drawing

Artists' vs. Student Grade

Pastels and colored pencils come in two primary grades: artists' and student quality. The artists' grade is made of the best-quality pigments, which are more lightfast (resistant to fading) and have a higher ratio of pigment to binder, making them brighter and more intense. Student-quality colors are of a lower grade, less resistant to light, and have a smaller amount of pigment in them.

Erasers

Erasers are usually thought of as tools to get rid of unwanted flaws and mistakes, but they are great drawing tools too. They can be used to create highlights (such as reflections), to lighten areas, or to create texture effects. There are several types of erasers for drawing, each with its own useful properties.

Kneaded Erasers

Made of a material resembling putty or gum, kneaded erasers can be an artist's best friends. They pick up graphite and charcoal without smudging and don't wear out quickly. Eventually, however, they do get dark and sticky (that's when it's time to replace them). They can be kneaded into any shape you need: tiny points, long and thin, flat, etc. Erase by tapping or dragging, kneading the eraser as you go to get a clean section with every tap. Kneaded erasers are soft, so they cause the least damage to your paper of any type of eraser. Their only limitation is that they aren't suitable for completely erasing very dark, in-depth marks. For that task, you'll need a vinyl eraser.

Gum Erasers

Gum erasers are soft and crumble as they erase. They leave a trail of "crumbs," but are gentle on paper. They are not very precise, however, and will not get rid of hard pencil marks. They are useful for general erasing and to care for delicate paper.

Rubber Erasers

These are common, and sometimes come in colors, like the pink erasers on the ends of pencils (avoid pink or tinted, however, because they can stain paper). Rubber erasers are firmer than gum and effective at removing pencil marks. They lift the medium and leave crumbs, but not as many as gum erasers.

Vinyl Erasers

Vinyl (or plastic) erasers are harder than all of the above. They are efficient at erasing dark graphite or charcoal, and they can even erase India ink from smooth paper. They can be tough on drawing paper, however, and if not handled

carefully, they can damage it. Don't use them as your go-to erasers, but they are good to have on hand, especially to deal with stubborn lines.

Eraser Pencils

These vinyl erasers come inside a casing, like a pencil. They can be sharpened to a point and used to erase details. They're not recommended for larger areas, because they can easily damage the paper.

Eraser Pens

These are like lead holders, encasing a vinyl eraser in the shaft instead of lead. They come in different thicknesses and refills are widely available.

Hand Broom (or Dust Brush)

Touching the paper with your hands can leave grease that could ruin your drawing. Use a hand broom to dust away eraser crumbs or other particles.

Eraser Pen

Blending Tools

Blending is the process of merging different shades together, so that each transitions smoothly into the next. There are several blending tools you can use to create soft, realistic tones.

Stumps

Stumps come in a range of sizes and hardness for blending graphite, charcoal, and pastel. They are tapered cylinders made out of tightly wound paper. You can get smooth gradations and tones with them. They can also be used to apply media directly for delicate effects. Use a cleaner side of a stump to smudge lighter areas (otherwise, you'd smear dark blotches into it). However, unless damaged beyond repair, save dirty stumps for smudging dark areas. They can be cleaned by lightly rubbing their tips on fine sandpaper.

Chamois or Cotton Cloth

A chamois is a piece of soft leather, excellent for evenly smudging large areas. You can fold it like a napkin and use it flat, or roll it around your finger for better control. You can create different effects by going over your drawing with light circular motions or straight

Blending Stump

lines across the area you intend to smudge. You can also use a cotton cloth, but it will lift less medium than a chamois, so the effect won't be as intense. Try both options to see what you like best for different uses.

Brushes

You can use brushes to blend charcoal powder or other dry media, or to give tone to an area. Flat brushes provide better control, while round brushes blend more evenly. They should be soft (hard bristles can leave marks), but not so soft they don't blend well. Synthetic brushes made for acrylic painting have a nice medium-soft feel. Test different types to find the ones you feel most comfortable with.

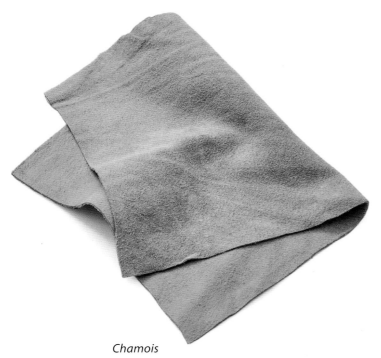

Chamois

Use a Blending Tool

Smudging with your fingers isn't advisable, because body oil left on the paper can create marks or inconsistencies in further applications.

Sharpening Tools

There are different ways to sharpen your tools, depending on the effects you want. A longer exposed core gives flexibility and lasts longer between sharpenings. Use the fine point of the tip for fine lines and details or the side for wider lines and shading.

Blades

You can sharpen graphite and charcoal pencils with an X-Acto knife or razor blade for long exposed leads. Always use a blade for charcoal pencils, which break easily in other devices. The following instructions are for right-handed artists (if you're left-handed, reverse them). With an overhand grip, hold the knife in your right hand. Hold the pencil in your left. With your left thumb on the dull side of the knife, slowly push the

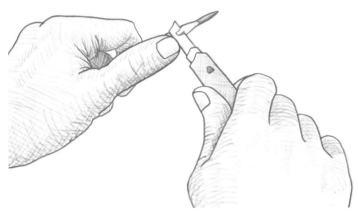

blade down the pencil shaft, taking off thin layers of wood. Rotate the pencil as you go, until you expose about a 1/2-inch of the core. Don't take off too much, or you'll break the charcoal. Sometimes removing the wood leaves a film of glue on the charcoal; remove it by rubbing with the blade. Use sandpaper to smooth any corners, and to sharpen the tip. Wipe off any powder residue with a cloth or tissue.

Sandpaper Pads

Sandpaper pads, used to smooth edges and sharpen tips, have a wooden base with sheets of fine sandpaper on top. When a sheet gets dirty, peel it off.

Electric Sharpeners

These are fast, but use restraint so they don't eat up too much of your pencils. I don't recommend them for colored pencils, as leads tend to break in them, and the blades can jam with soft materials.

Hand Sharpeners

These are in every child's pencil case, and are best for colored pencils using a quality sharpener. Colored pencils often need just a trim at the tip, and you can give a hand sharpener just enough of a turn to get the point you want. When it's not working as well as it once did, or is breaking leads, it's time to change the blade or get a new one. Some come with two holes of different sizes. The larger one is often used for colored pencils, while the smaller one is for graphite pencils, producing a longer exposed lead.

Sharpeners for 2mm Leads (in Lead Holders)

These include lead pointers, which look like mini hand sharpeners, and rotary barrel sharpeners. On top of the barrel sharpener, there's a big hole for sharpening and two small ones of different depths for measuring the length of the lead you want to sharpen. Let the lead fall to the bottom of one of the small holes, then adjust the lead holder to hold it at that level. Insert it in the large hole, and rotate until you feel no friction. When pulled out, it will be sharp and may have dust on it. This type of pointer often comes with a cloth for cleaning that dust. If you use the shorter length, you'll get a good point. If you use the longer length, you'll get a needle-sharp point.

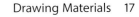

Pen and Ink

Artists have used pen and ink for thousands of years. Ink drawing is exciting, because the marks are smoother and sharper than other media. It is also challenging, because it can't be erased. You may first want to sketch your drawing lightly with a pencil, then go over it with ink. It's also best to use lint-free paper so that pens don't clog. Also make sure to use lightfast drawing ink, rather than ink intended for writing or illustrations (which will fade when exposed to light).

Nibs and Handles

The nib is the pointed end of a pen that distributes ink onto the paper. Historically, it is mounted on a handle, then dipped in ink to draw with. It produces a clean line when used correctly. When making a mark, pull the pen to glide it along, rather than pushing it (which produces uneven blotches). Some nibs are hard, intended for even lines, and some are flexible, providing a broader mark as you increase pressure on them. There are a large variety of generally inexpensive nib sizes, shapes, and flexibility. However, this technique is not the most practical, since you need to keep dipping the nib in the ink after every few lines. Also, the line will be a little thicker just after dipping, but as the ink runs out, it becomes thinner and thinner. With

practice, you can use this to your advantage, making the intended thicker lines right after dipping, and waiting to make the thin ones that you need when the ink is running out.

Fountain Pens

Fountain pens with refillable or disposable cartridges inside are the modern version of the nib and handle. Therefore, constant dipping is avoided. They can be used for writing or drawing, and the nib of most fountain pens is rigid, which doesn't allow for much variation in line width. However, most can be turned around to draw with the back side of the nib, producing a thinner line than in the usual position. There are also some fountain pens with more flexible nibs that are ideal for drawing.

Brushes

Brushes can be used with ink for details or background washes. Their size and shape will influence the marks they leave. Use larger flat or round brushes to deliver broad strokes and fine round brushes for thin lines.

India Ink

India ink, usually in black, is most commonly used for drawing, though it does come in colors. It's waterproof and permanent once dry. That's great, because you can paint washes over it without smearing, but it also means that when finished, you must thoroughly clean your nib before the ink dries in it, or the pen will be ruined (or you'll need a strong solvent to clean it). India ink can also be thinned with distilled water to paint lighter washes (tap water is not good, because the minerals and fluoride in it disturb the ink's chemistry).

Non-Waterproof Inks

There is a kind of India ink that is not waterproof, even if the ink has dried on the paper, that can be used to your advantage to create some beautiful effects. You can also use watercolor paint with water as your "ink." However, if you need the line to stay in place, use waterproof ink.

Fountain Pen, Soft-Fine Nib

Nib and Handle

Fountain Pen Sketch

Technical Pens and Markers

Technical drawing pens and markers have pointed tips suitable for making very precise lines. They are easy to use, and finely pointed types are ideal for details. They dry quickly, and many have water-resistant inks. To prevent work from deteriorating over time, choose those labeled as archival, acid-free, premium pigmented inks.

Avoid Direct Sunlight

Don't display drawings with color or ink in direct sunlight, because they'll eventually fade.

Paper

The right paper is essential to results, what materials you use with it, and what you aim to achieve. A hard pencil will damage inexpensive paper such as newsprint, while a fountain pen works better on smooth paper than rough. If you want lots of detail, hyperrealism, or a super-smooth metallic look, choose a smooth paper. When drawing realistic skin, a fine-grain paper can give a realistic finish by itself. If you are using charcoal or pastel, especially with quick, bold strokes, you will do better with a paper that has more texture to hold the medium.

You must also consider the tonality of your drawing, or how dark you want it to be. Papers with more grain, or tooth, hold more lead, so marks look darker. Smooth papers have little tooth, so marks look lighter. Unless you're using a pen or marker, I recommend your paper always have at least a little grain, even if fine, as it lets you work more effectively, and the result will be more artistic than with entirely smooth paper. With time and experience, you will find your favorite combinations.

Newsprint

Use inexpensive newsprint pads for multiple gesture drawings and quick sketches, preferably in a large size such as 18" x 24". This cheap paper isn't suitable for high-quality drawings (it yellows over time), but it's great for experimentation and practice.

Cotton Papers

Cotton papers are considered to be of the highest quality. They are referred to as being 100% cotton rag. They can handle heavy erasing and working without showing wear.

Paper Weight

A paper's weight is its thickness. Drawing paper should be thick enough to hold the material and not be damaged by erasing. Paper weights are listed in pounds, with 25 lb being very light (tracing paper), and the heaviest papers (used for painting, such as watercolor papers) up to 140 lb. Newsprint is 30-35 lb, sketching paper is usually 50-60 lb, and 70-80 lb is generally suitable for finished drawings. A heavy-weight drawing paper of 90 lb or more allows room for repeated erasing when working on final finished drawings.

Lower vs. Higher Grade Paper

Keep newsprint or lower-grade sketchpads for practice. Papers labeled "drawing" tend to be thicker and better quality than ones labeled "sketch," but some sketch papers are fine for drawing. Using high-quality acid-free archival paper helps drawings last for decades, but save it for your final drawings.

Toned Paper

Toned paper can be excellent when chosen wisely. A gray paper can give you the middle tones of your drawing; all you have to do is draw the darks and lights. If you're drawing a bird in the sky, you could choose blue paper to give the right background and feel.

Bleed-Proof Paper

This is a smooth paper treated to prevent ink bleeding through to the other side, allowing for clean lines. It's great for ink, but not for graphite or charcoal (lacking tooth, the medium doesn't adhere properly).

Paper Textures

There are three main types of drawing-paper textures: hot press, cold press, and rough. Hot press is smooth, best for fine details, blending, and hyperrealistic looks. However, it is often not the best choice for pastel or charcoal, since it doesn't have enough tooth. Cold press and rough each have a coarser finish, with more texture, and are generally best for pastel and charcoal.

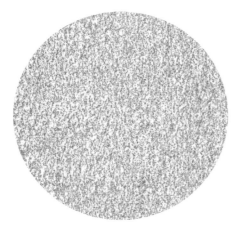

Hot Press

Cold Press

Rough

Gray Scale Value Finder

A gray scale value finder is a tool that shows values—the lightness or darkness in an image—from the lightest white to the darkest black, with grays in between, making it easy to compare them. Gray scale value finders sometimes come with holes in them for viewing values through. To do this, raise the scale in front of your subject, reference photo, or art. View it through the holes to find its closest values as they correspond to those on the card, which will help you use the correct values in your drawing.

Mahl Stick and Bridges

A mahl stick is used to rest your hand on, to draw without touching the paper and smearing your work. Hold the end of the mahl stick with one hand, lean the ball end on the table, easel, etc., and rest your drawing hand on it. Bridges are similar, but they sit on a horizontal or nearly horizontal tabletop without having to hold them. With either, both ends should clear your drawing.

Fixatives

Fixatives usually come in spray form and are essential for protecting drawings from smudging. Workable fixatives reduce smudging while you work on your drawing. Non-workable fixatives are for setting final drawings with a permanent protective coating. Fixatives come in matte or glossy finishes.

Get Good Materials

An artist can create a masterpiece with very few materials, so lack of expensive supplies is no excuse for bad art. However, get good materials, because they can also make a big difference in your work and make your life a lot easier. Quality materials are also more permanent, which is crucial if you want your work to last.

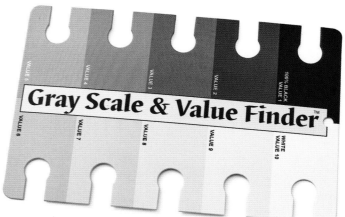

GRAY SCALE VALUE FINDER

Place it on a reference photo or piece of artwork, or view it between your eyes and subject matter to match the gray values on the card to the colors you are seeing.

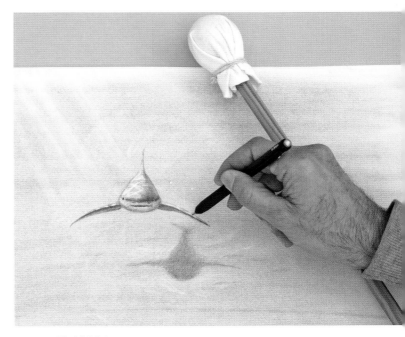

Using a Mahl Stick

To watch video tutorials related to this chapter, visit: www.fineart-tips.com/Chp1

The Basic Elements of Drawing

When you draw realistically, you're trying to capture the appearance of three-dimensional objects on the flat surface of the paper. To do this, you need to pay attention to the basic elements of shape, color, value, and edges.

Shape

Shapes are outlines of objects, either overall large shapes or smaller shapes within larger forms. It's important to begin with larger masses, simplify them by drawing basic geometrical shapes first, and then add details.

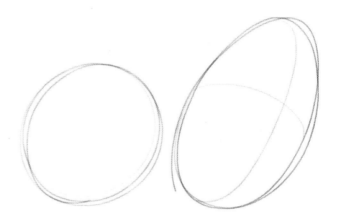

Rounded Shapes—circles, ovals, egg shapes, or spheres

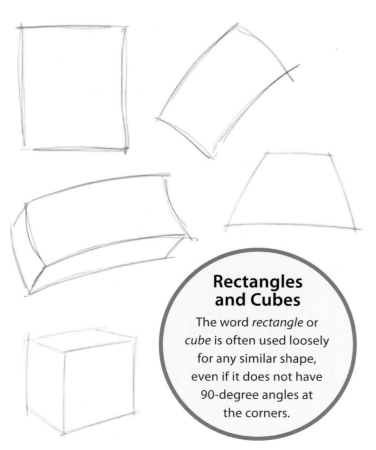

Rectangles and Cubes

The word *rectangle* or *cube* is often used loosely for any similar shape, even if it does not have 90-degree angles at the corners.

Boxes—squares, rectangles, or cubes

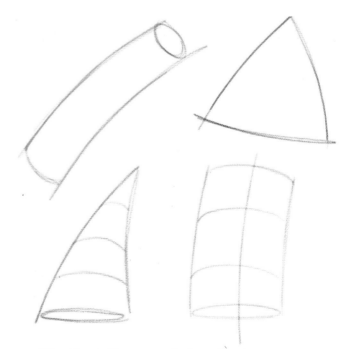

Other Simple Shapes—cylinders, triangles, or cones

When you want to draw something, let's say, a feather, you must first reduce it to a basic shape, such as a rectangle. Once you're satisfied with the size and proportions, you can then add details.

1. Block in the Basic Shape

2. Draw Smaller Shapes and Details within Guidelines

3. Erase Block-In Lines

Color

Color is a subject that could take up a whole book, but here are the basics to get you started. Three simple properties of color are hue, colorfulness, and value.

Hue

Hues are what we call specific colors of the rainbow, such as red, orange, yellow, etc. These colors can also be arranged in order on a color wheel.

Primary, Secondary, and Tertiary Colors

The three essential hues are the primary colors: blue, red, and yellow. They can be combined to create other colors, but can't be produced by mixing other colors. Next come the secondary colors: violet (or purple), green, and orange. They are each made by mixing two primary colors. Blue and red create violet; blue and yellow create green; red and yellow create orange. Then there are tertiary colors, sometimes called intermediate colors, made by combining a primary color and a secondary color together, or by mixing two secondary colors.

Complementary Colors

These are pairs of colors opposite each other on the color wheel that produce neutral colors like grays when mixed. You can create the complement of a primary color by combining the other two primary colors. To get the complement of blue, which is orange, mix yellow and red. Orange is the complement of blue, and blue is the complement of orange. The complement of yellow is purple, produced by mixing blue and red. The complement of red is green, a combination of blue and yellow.

Color Types

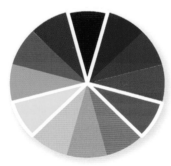

Primary
Red, Yellow, Blue

All other colors are derived by mixing these three hues

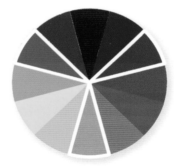

Secondary
Green, Orange, Purple

Colors formed by mixing two primary colors

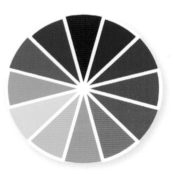

Tertiary
Yellow-Green, Red-Orange, Red-Purple, Blue-Purple, Blue-Green, Yellow-Green

Colors formed by mixing a primary color and a secondary color

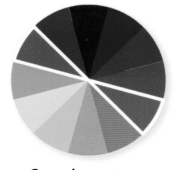

Complementary
Colors that are opposite each other on the color wheel

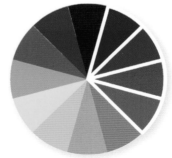

Analogous
Analogous color schemes use colors that are next to each other on the color wheel

When placed next to each other, complementary colors create strong contrast. To make a red apple really stand out, draw it on a green background. Additionally, the shadow of an object may contain a tint of its complementary color. For example, the shadow of a yellow banana may have a little purple in it, to separate the object from the shadow even more than it would by just making it darker.

Analogous Colors

Colors that are next to each other on the color wheel— red and orange, orange and yellow, blue and green, etc.—are called analogous. Used together, they create color harmony. You can use analogous colors to create changes in tone. For example, to lighten a red apple, you could use white, but that might dull the vibrancy of the red. A better approach might be to layer on a light orange, to lighten the tone while preserving its vibrancy. If you would like to darken a side of the apple, and you use black, it could look muddy. A better solution might be to layer in purple, which would darken it while keeping the colors clean.

Color Temperature

The color wheel can also be divided into warm and cool colors. Warm colors are reds, oranges, and yellows. Cool colors on the other side of the color wheel are blues, greens, and violets.

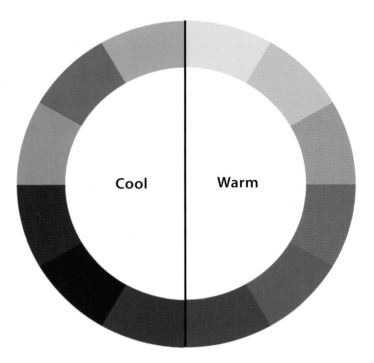

Cool **Warm**

100% Colorfulness

Colorfulness

Also called chroma, colorfulness is how vivid and intense a color is, or how far it is from gray. Mixing a color with its complement or with a neutral color (such as black, gray, or white) reduces colorfulness, bringing it closer to gray. This is called toning it down, or neutralizing it.

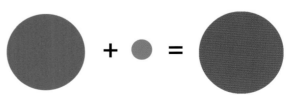

Toning a Color Down with Its Complement

Value

Value is the lightness or darkness of a color. There are an unlimited number of values, but a value scale, as shown here, may simplify it to ten. Black is often 1, while white is 10. Value is the only property of color you work with when drawing in black and white.

Light pencil pressure produces light values, while hard pressure produces darks. When values are close to each other, it "flattens out" a drawing, so nothing stands out. Contrasting values make shapes separate from each other, creating volume and dimension.

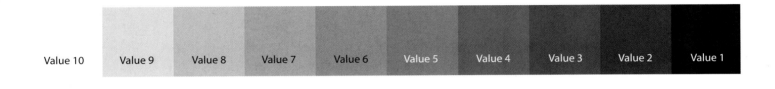

| Value 10 | Value 9 | Value 8 | Value 7 | Value 6 | Value 5 | Value 4 | Value 3 | Value 2 | Value 1 |

USE CONTRASTING VALUES

Working with a small range of values may result in "flat" drawings, but with contrasting values, you can show volume and light. To make things shine, you need high contrast.

Flat Values

Contrasting Values

Edges

Edges separate shapes or elements from each other, creating boundaries and transitions that can be sharp, gradual, or in between. They can be categorized into hard, firm, soft, and lost.

Hard edges are sharp and definite, drawing the attention of viewers, especially if accompanied by high contrast. They are often used in primary areas of interest. Firm edges are a step softer, creating a transition from one shape to the next, often used to draw objects that are not the main center of attention. Soft edges generate a smoother transition or gradation. They are not as obvious, and can be used when drawing soft shadows on a sphere, or soft materials, like hair or fabric. Lost edges are so smooth that they can't be easily seen, visually merging together and losing the boundary between shapes. They often occur when adjacent objects with soft edges have the same or close values.

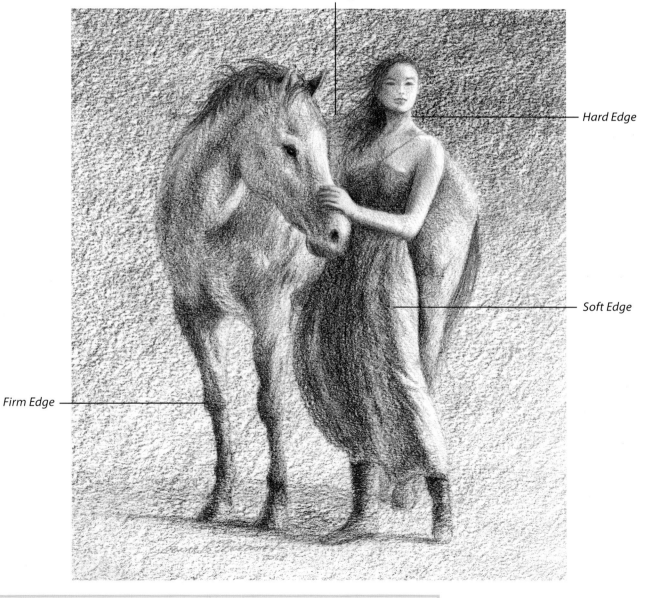

Lost Edge

Hard Edge

Soft Edge

Firm Edge

To watch video tutorials related to this chapter, visit: www.fineart-tips.com/Chp2

CHAPTER 3

Beginning to Draw: The Essentials

In this chapter, you will learn how to position your paper, how to hold your pencil, and how lines work.

How to Position Your Paper

Many of us begin drawing the way we're taught to write, with a tight grip on a horizontal surface. But this isn't the best arrangement, because your hand rests on the paper, causing short movements and tight lines. You're also looking at the paper from an angle, distorting shapes and proportions. And if you're working on a large drawing, it's hard to reach the top.

It's better to stand at an easel if possible. You see your drawing straight on, and your hand doesn't sit on the paper, for more fluid strokes using your arm. You can also step back for another view. If drawing from life, position your easel so you see your subject and your drawing at the same time with your paper to the right of your subject if right-handed (left if left-handed). This places your paper in front of your arm. The height of the paper should be mostly at shoulder level or a little lower. You can also sit with your surface at about a 45-degree angle. Secure your paper to a drawing board, sit on a chair, and place your board on your lap, resting it on another chairback. You should be able to look at your subject above the easel, and at your drawing.

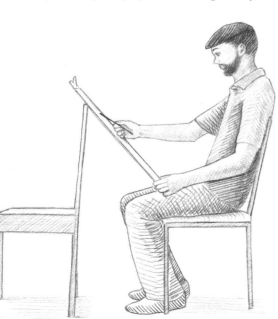

Sitting with a Drawing Board

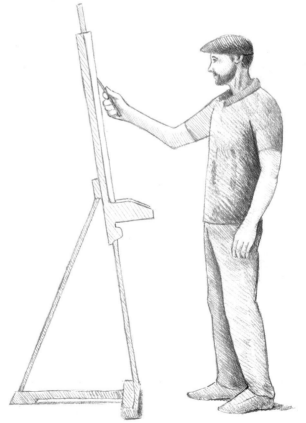

Standing with an Easel

How to Hold Your Pencil Like a Boss

There are probably as many ways to hold a pencil as there are artists. Here are some useful and helpful grips to try. While a new grip may feel awkward at first, don't give up! Various grips allow for a wide range of marks—thin, broad, fluid, deliberate, precise, etc.—that add up to richer drawings. If you always hold your drawing tools the same way, you limit the range of possibilities they can deliver.

The Five Main Pencil Grips
Practice the following grips until they feel comfortable and become second nature. Each has its own purpose. You might even use all of them in a single drawing—overhand for your initial sketch, for great fluidity of line; brush grip to define shapes in finer detail; finger on tip for shading; back to brush grip for refining lines; tripod for delicate details; etc. Mastering these grips will imbue your drawings with variety and richness. To transition to the second-nature stage, try the following exercises with each one:

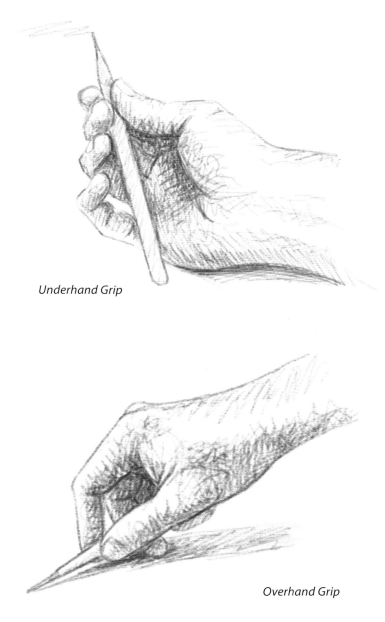

Underhand Grip

- Draw ovals and circles over and over
- Draw two dots a distance apart, then a straight line uniting them, repeating at different angles
- Draw three dots, then a curved line to connect
- Draw four dots in a rectangle shape, then draw an oval that touches all four points

Once you're used to these grips, you'll have a hard time believing you ever drew without them.

Underhand Grip
Palm facing up, hold the pencil between your thumb and index finger, or against all four fingers. This grip favors loose movement of the arm from elbow to shoulder. It produces a flowing, sweeping line, excellent for sketching and shading with the side of the lead. It is best for drawing at a vertical or near-vertical angle, such as when you have your paper on an easel or vertical drawing board, and for large drawings. You don't need to lay your hand on the surface to sustain this grip while standing at about arm's length from your drawing surface.

Overhand Grip

Overhand Grip
This is similar to the underhand grip, but with the palm facing down. Hold the pencil loosely between index finger and thumb, stabilizing with your other fingers. This lets you use the side of the lead instead of just the tip. This grip is one of the best for working on large drawings. It works on vertical, tilted, or horizontal planes. Again, move your whole arm from the shoulder for fluidity. A variation of this grip is holding the hand vertically with the pinky side facing down.

Tripod Grip

The tripod grip is the same one traditionally taught for writing. The thumb, index finger, and middle finger hold the pencil, while the hand rests on the drawing surface. This grip works for fine detail, allowing minute control from the fingers using only the tip of the pencil. The closer your fingers are to the tip of the pencil, the more control you have. However, you also risk getting stiff, jagged lines, so use the tripod grip only for small details.

Brush Grip

This grip is between the overhand and tripod. The main difference from the tripod is that you grip the tool farther from the tip for more fluid motion. You can use it with or without elbow support. Generally, the farther you hold the pencil from the tip, the looser your lines can be. Try to move your whole arm using your elbow and shoulder, unless you are working on a small drawing.

Finger on Tip

Hold the pencil between your middle finger and thumb while pressing on the tip with your index finger. This grip is used when you need to lay a lot of lead on the paper, since the pencil is almost parallel to the surface. It is useful for shading and filling in large areas. It is also effective for vertical lines by placing the tip of your pencil facing up (if you are drawing on a vertical surface), and moving the whole arm straight down, delivering a strong mark.

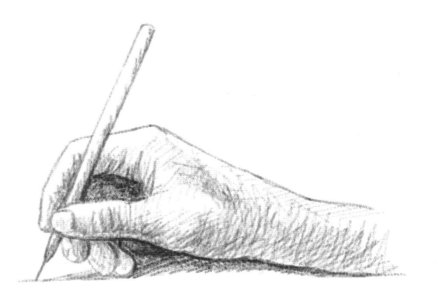

Tripod Grip

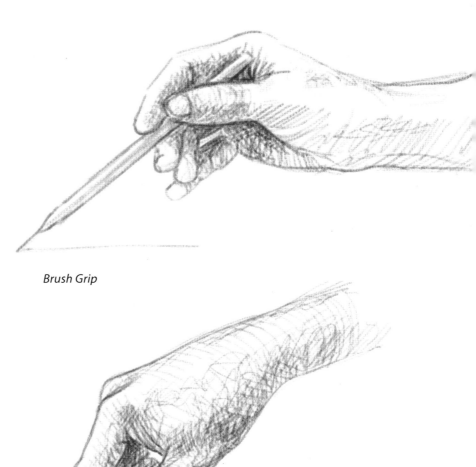

Brush Grip

Finger on Tip

Making Lines

Lines are the most basic form of drawing. They can be powerful or delicate, smooth and flowing, jagged and rigid. Of course, an essential element for making good lines is holding the pencil correctly, as described above. The other key to a professional stroke is making the motion with your whole arm, lightly flowing over the surface without resting your hand on it.

Most drawings begin with lines, then values are added, but drawings can be entirely rendered with lines. A drawing usually begins with light, loose lines, and then you can come back with stronger lines and details. Lines used to define an object's outline are called contour lines, but lines can also add volume to an object, helping to define light and shade. You can make thin, light lines on areas that are illuminated on your subject, while increasing darkness and thickness for shadow areas. Strong lines with hard edges will pull attention to that area, while faint or lost lines will remain unnoticed at first. Different lines of varying darkness and width give richness to your drawings. In general, continuous lines look much better than those that are broken or jagged.

Short, Stiff Lines Look Amateurish

Long, Flowing Lines Look More Professional

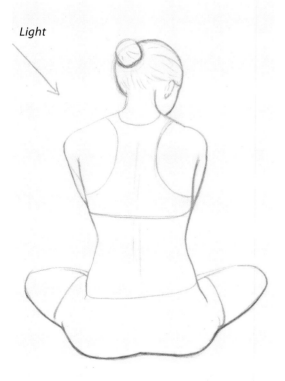

Light

Varying Lines Can Show Light and Shade

Strong Lines Pull Viewers' Attention

To watch video tutorials related to this chapter, visit: www.fineart-tips.com/Chp3

CHAPTER 4
First Exercises

When a runner wants to improve his time, he doesn't just run the distance over and over. Doing it again and again is part of it, but he also does sit-ups to get stronger and other drills to improve. When a singer trains, she is first given breathing exercises, then other skills to master, and months of preparation go by before she performs a song for an audience.

The same concept applies to visual artists. There are exercises you must practice to improve before creating a masterpiece, or at least a beautiful drawing. The exercises in this chapter aren't intended to produce instant results, but if you do them diligently, over and over, you will see improvement. Take your time. What counts is your effort. What you get is directly proportional to the work you put in.

EXERCISE 1: Contour Drawing

Purpose: Enhance eye-hand coordination and improve your perception of proportion.

WHAT YOU NEED
- Sharp 3B pencil or fine marker
- Inexpensive paper, about 16" x 20"
- Drawing board
- Large rubber bands or clips

Fasten your paper to your drawing board with rubber bands or clips. Sit on a chair, resting the lower edge of your board on your legs with the upper part on the back of another chair (or a similar arrangement). Position your subject in front of you.

Observe the contour of your subject, its silhouette. Pick a point on that silhouette, any point. Place the tip of your pencil on the paper to start drawing the outline, focusing your vision on the location where you want to begin. Move your sight slowly around the silhouette, while at the same time drawing the contour with your pencil without looking at your drawing. Move the pencil over the paper as if it were connected to your vision,

slowly. Draw the contour of your subject at the same time you look at the different parts, not before or after. Imagine your pencil is actually on the object, and that it moves over the surface as you advance your sight.

Try to stop as little as possible, and don't lift the tip of the pencil from the paper. If you arrive at a dead end, and need to come back to draw another feature, don't raise the pencil tip. Just back up and draw another line. If at any point you feel lost, look at your paper and find where you are. Place the tip of your pencil where it should be to continue the drawing, and then continue with the exercise, slowly moving your eyes around the contour, drawing the line at the same time. Don't erase.

Don't rush. Give yourself ten or fifteen minutes for each drawing. Do this each day until you have at least five hours of practice, even if you feel like you "get" this exercise sooner. You're not trying to get a beautiful drawing, or to understand the exercise. You're working on practicing your perception and coordination. The time you put into the drill will improve what you get out of it. Correctly performing this drill will improve your skills, even if you are more experienced. But don't skimp on the time.

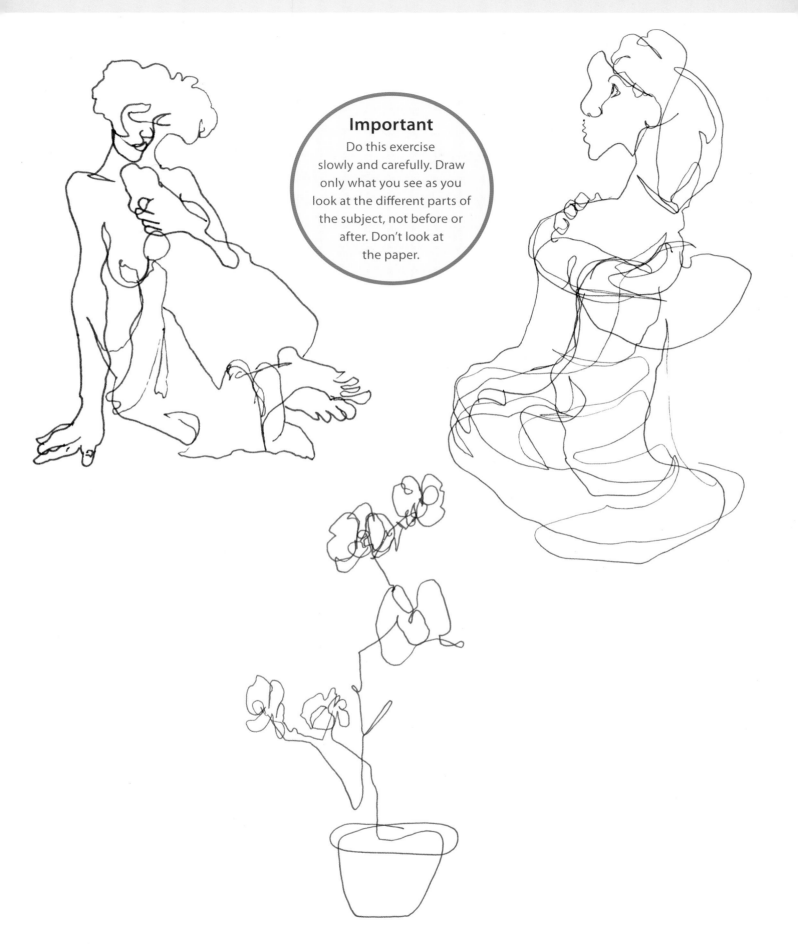

Important

Do this exercise slowly and carefully. Draw only what you see as you look at the different parts of the subject, not before or after. Don't look at the paper.

EXERCISE 2: Expressive Drawing

Purpose: Capture expression in your drawings.

WHAT YOU NEED

- A model (friend, family member, etc.)
- Dull 3B pencil or marker
- Lots of inexpensive paper, about 9" x 12"
- Drawing board
- Large rubber bands or clips

With this exercise, you'll make many fast sketches, so be sure you have lots of inexpensive paper (like newsprint). Ask your model to hold one-minute action poses as if he or she were walking, stretching, throwing, boxing, etc. Start drawing as soon as the model is ready, then try to capture the action. If you don't have a model, you can go to public places where people are moving and sketch there, where you might find a person sweeping, a worker making holes in the ground, someone walking, dancing, etc.

With this exercise, you aren't concentrating on the contour, as in the last exercise. The key here is to capture the *action* of the pose. If a model is throwing something, draw the force in the arms, the energy of the body, and the strength of the feet on the ground (or moving, if that's the case). If the model has an open hand, draw the action of the fingers stretching, almost exploding. Or draw the power of a tight fist.

Let your hand and pencil move freely. Don't judge. Don't think too much. Feel the energy of the action, and let your pencil go. Seek to understand the impulse driving the action of the model. For example, if a martial artist is starting the movement of a kick, try to perceive and draw the energy of the pose and what comes next—his leg stretching with speed and power.

Draw with rapid movements and continuous lines as if scribbling. Another person may not recognize what

Reacting to the Gesture

"The drawing may look meaningless, but the benefits that you have at the moment of reacting to the gesture will pay large dividends eventually."

- Kimon Nicolaïdes

> **Expression and Action**
> The key point is to capture the expression and action of the subject, not its shape.

you did, but that's fine. This is not meant for an exhibit. Make hundreds of these sketches, and you will gain an expressive way of working that will enhance all your future work.

Try shortening the length of the poses, capturing the gist in five seconds with fast lines. Try ten seconds, thirty, back to one, two minutes, three minutes, etc. But no matter the length of the pose, try to capture the whole expression in the first five seconds, then add details later if you like.

This can be applied to very simple poses, such as a girl combing her hair, or an old man sitting. You should be able to perceive and express in your drawing the intent of the girl, with the motion of the brush gently sweeping her hair, or the old man resting and relaxing his body on a stool for a moment. Each action begins with an intention that drives the resulting pose. Strive to perceive that intent. What caused the jump; was it joy? What clenched the jaw; was it anger? What prompted the running; was it fear?

After drawing short poses, when you do a longer one, you may feel you've completed it before the time is up. Don't worry. Keep drawing, looking for the energy of smaller parts. Again, try five-second sketches, then ten, thirty seconds, one minute, two minutes, and three minutes. Again, do these exercises for at least five hours.

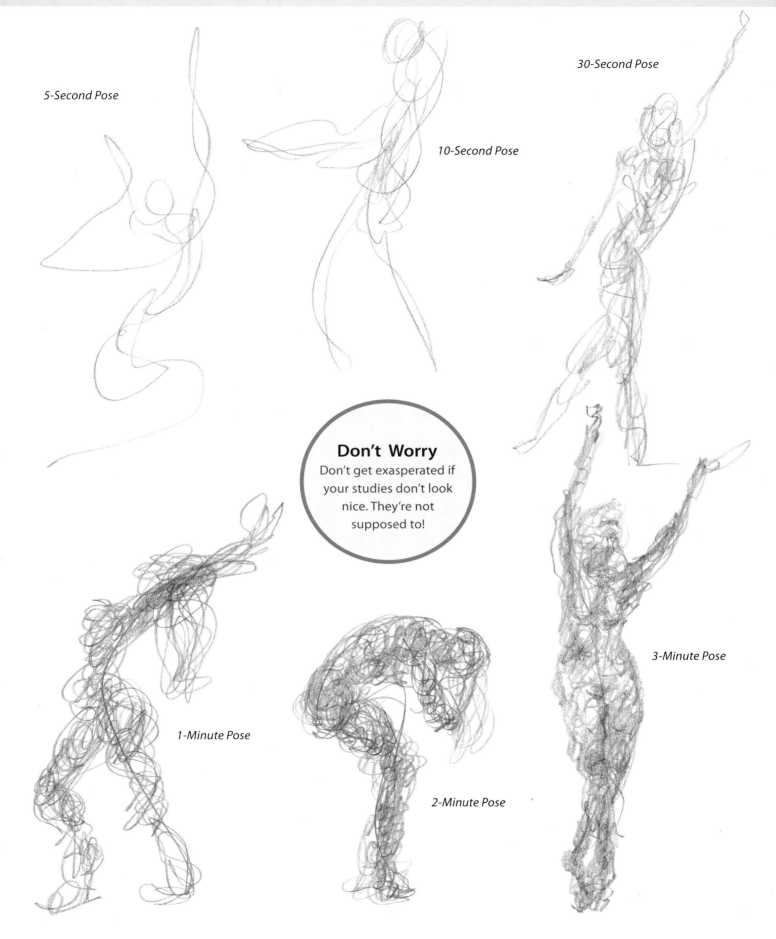

5-Second Pose

10-Second Pose

30-Second Pose

Don't Worry
Don't get exasperated if your studies don't look nice. They're not supposed to!

1-Minute Pose

2-Minute Pose

3-Minute Pose

EXERCISE 3: Drawing from Memory

Purpose: Capture expression in your drawings.

WHAT YOU NEED

- A model (friend, family member, etc.)
- Dull 3B pencil or marker
- Inexpensive paper, about 9" x 12"
- Drawing board
- Large rubber bands or clips

Have your model hold a pose for five seconds, then leave from sight. Observe the pose for those five seconds without drawing. Once you can't see the model, draw him or her in a similar way to the last exercise on expressive drawing, giving yourself about two minutes. After doing a few five-second poses, have the model hold a pose for only one second, and then leave. Again, observe the pose for that second, and then draw only when the model is no longer in sight. Repeat this until you feel confident that you can capture the expression of a pose at a glance, and draw it from memory. Do these exercises for about three hours total, perhaps for about fifteen to twenty minutes daily over the course of a week or two.

Again, if you don't have a model, you can do this exercise by going to places where there are people in motion. Look at someone for five seconds, turn around so you can't see the subject, and then draw from

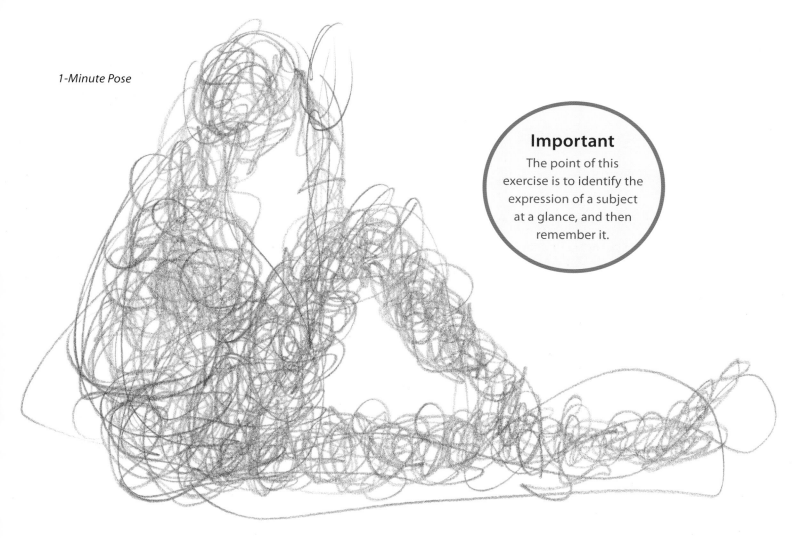

1-Minute Pose

Important

The point of this exercise is to identify the expression of a subject at a glance, and then remember it.

memory for a couple of minutes. Then repeat, looking at your model for just one second.

You can also use objects, such as a coffee cup, flower, etc. Observe for five seconds, then turn around and draw it. After many five-second sketches, look at your subject for just one second, then draw it. If you perceive a flow, follow it. If you're drawing a plant, start from its base in the soil, then its stem, then its branches, the leaves, and out to its flowers. That is how the plant grew and developed. Follow this flow.

3-Minute Pose

Objects Also Have Expression

Objects have expression as well as people, such as the force that dictates how a tree stands, how water flows, how a nail is fixed on a wall, how a feather lies on the ground, how a dress falls on a girl, etc.

To watch video tutorials related to this chapter, visit: www.fineart-tips.com/Chp4

Basic Techniques

Mastering the fundamentals of drawing gives you the freedom to create what you want. From quick sketches to sound structures, it's essential to understand and practice basic techniques, because they give you the foundation on which to build your masterpieces. You're always putting together different approaches or techniques when drawing. With practice, this becomes second nature, but it's important at the beginning that you learn each technique individually.

Sketching

It takes a lot of sketching to draw like a pro. No one sits at a piano only a few times and says they don't have talent because they can't perform Beethoven's *Moonlight Sonata*. Not before months of practice for hand placement, scales, etc. In the same way, to draw the figure correctly and with confidence, one needs to do a lot of sketching. You must learn the proper techniques; otherwise, you may be perpetrating an error when practicing, and that would do you no good.

Gesture vs. Structure

Gesture and structure are concepts that can be seen as opposites, but that work together to complement each other.

Structure is the solid foundation that holds a subject in place. It is composed of three-dimensional forms simplified into basic shapes such as cubes, spheres, and cylinders. For example, in the human body, we have the rib cage, shoulder bones, arms, etc.

Gesture is not as tangible. It's the energy in our drawings. It's the connection between the parts. It's what unites them. In basic drawing,

gesture is very important, and should be done before structure. Otherwise, we take the risk of our figures looking stiff, robotic, and lifeless. We also find gesture in other organic, fluid shapes such as in a blade of grass, in trees, rivers, and clouds.

Structure without gesture can be lifeless.

Pure mood lines with no structure at all make no sense.

Gesture and structure play together to give life and solidity to a drawing.

Gesture Drawing

Gesture drawing captures action, mood, or the motion of a subject. We build basic shapes, simplifying, abstracting, and taking what is essential. Don't worry about details and other information for now.

Gesture drawing loosens your drawings, getting rid of stiffness in your strokes. Try to make long, continuous, fluid lines. In the beginning stages, use the side of your lead to get soft, wide lines. Here are some examples.

I made these sketches using an electronic tablet, but they can also be perfectly done with an HB pencil or with a sanguine pencil (which would give about the same color as shown on the next page).

DANCER WITH RED DRESS

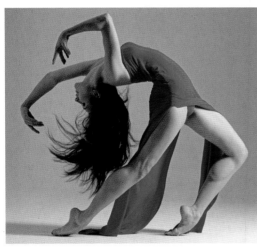

1 Observe the action of the figure as she bends backward.

2 Draw a mood line from the center of the neck, through the torso and pelvis area, and through one leg. Always draw mood lines lightly.

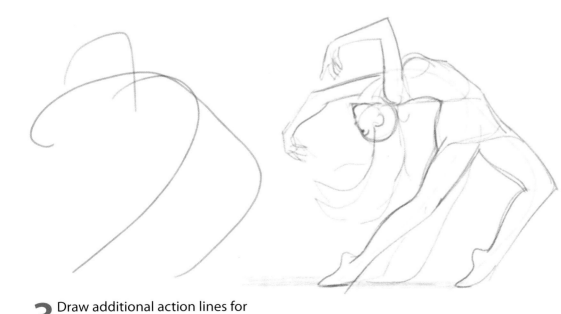

3 Draw additional action lines for her other limbs, the arm and legs.

4 A circle indicates the cranium. Draw lines for the face, jaw, and curving neck. Make an oval for the rib cage. A trapezoid-like shape indicates the pelvic area. Roughly draw the shapes of the torso, hips, and legs. Don't worry about detail. This rapid sketch shouldn't take more than two minutes.

DANCER IN BLACK

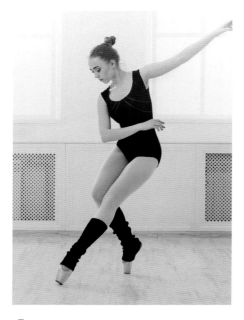

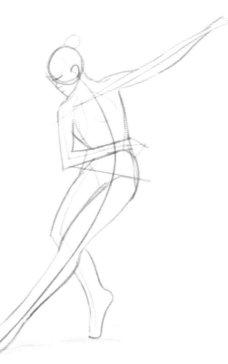

1 Observe the photo.

2 Begin by sketching the mood line from the center of the base of the neck through the torso, pelvic area, and through one leg.

Tilt of the shoulders

Tilt of the hips

3 Mark the tilt of the shoulders and hips. Draw mood and action lines for the arms and the other leg.

4 Make a circle to indicate the cranium, then lines for the face and jaw. Draw the rough shapes of the torso, legs, and arms. No detail: concentrate on capturing the pose, the action, and the mood.

5 This gesture drawing is complete by adding just a few details and erasing the action lines, taking only two minutes or so.

Line and Value Sketches

You must understand gesture drawing, but now that you do, forget about it for a moment! In drawing, sometimes techniques seem to contradict each other, but an artist must know and master each separately. Eventually, you'll use most of them in your drawings.

Structural Sketch (or Line Sketch)

With structural or line sketching, you give your drawings a solid foundation with correct proportions (detail and shading come later). When doing a line sketch, pay attention to the structure of the subject, focusing on the proportions and placement of parts. In this example of a structural sketch, you can see the guidelines for the axes of the glass and of the lime, as well as the relationship of one object to the other.

Value Sketch (or Form Sketch)

Values are the degrees of darkness or lightness in a drawing or painting. With "form" we mean the shape of something. When doing a value sketch, you will focus on the lights and the darks. This gives you the volume of the subject and helps you show the three-dimensional shape of it. You can do a pure value study or sketch, but it is usually combined with a prior line sketch that defines the basic structure and proportion, as seen here.

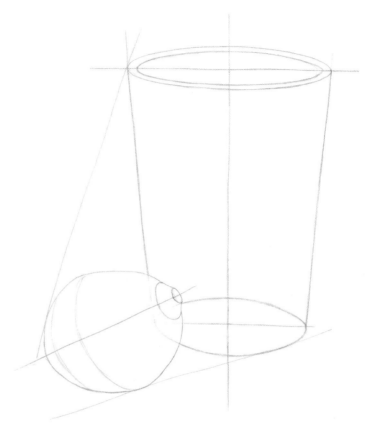

Structural or Line Sketch

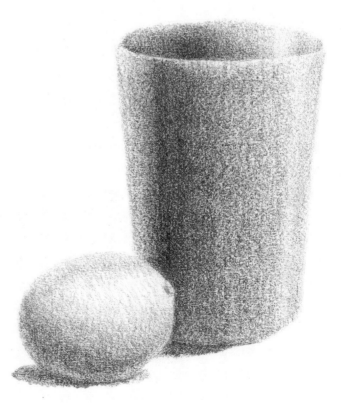

Value or Form Sketch

Using Basic Shapes

A great way to simplify what you are drawing is to reduce it to some basic geometrical shapes. They can be two-dimensional or three-dimensional shapes. For the following examples, we'll use basic two-dimensional shapes, and give examples of three-dimensional shapes once we go over the rules of perspective later in the book. Look for the most basic geometrical shapes in your subjects, such as rectangles, circles, and cylinders. Study how they relate to each other with regard to size and location.

DRAWING A CHICK

WHAT YOU NEED

- HB pencil
- Eraser
- Sketch paper, about 8½" x 11"

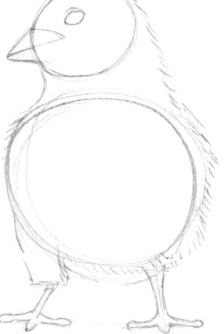

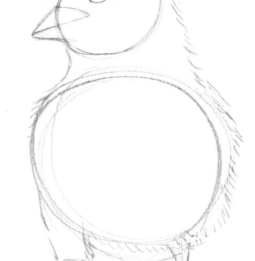

1 Reduce the shapes of your subject to their most basic, such as an oval for the head, a circle for the body, a triangle for the beak, and a rectangle for the upper part of the leg, with some lines for the feet.

2 With the shapes as a basic structure, sketch the body shape that unites and covers those figures. You can start making the feathery look as you go.

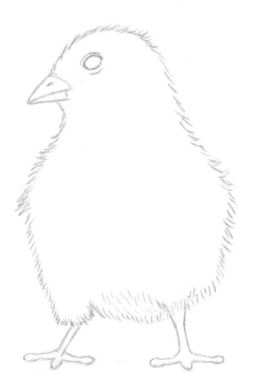

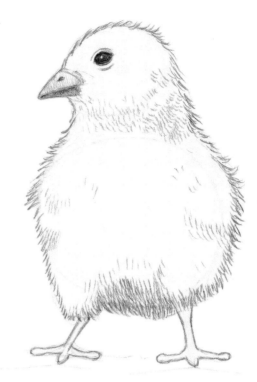

3 Erase the basic shapes and define the body better. Add more detail, such as the beak and more of the feathery outline all around.

4 Start shading within the body by making very short lines in the areas that are catching the most shade, such as around the neck and the lower part of the body. Fill in the eye, leaving only a small reflection. Lightly fill in the beak.

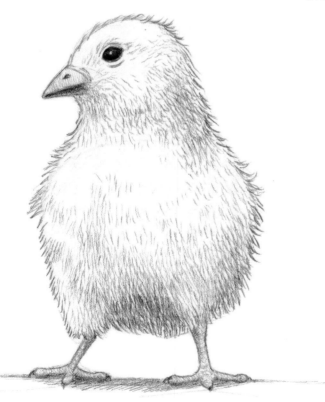

5 For mid-tones, continue making short lines but with less pressure. Leave the areas catching the most light blank. Fill in the legs, giving them texture with light lines across the legs and toes (horizontally for the legs and vertically for the toes). Make a line for the ground and draw a shadow under the bird.

DRAWING A BEAR

WHAT YOU NEED

- HB pencil
- Eraser
- Sketch paper, about 8½" x 11"

1 Draw a large rectangle for the body, a smaller tilted box for the neck, and a circle for the head.

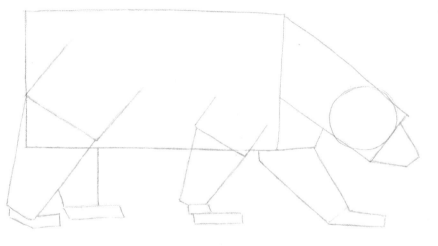

2 Add shapes to simplify other body parts. Squares and triangle-like shapes for the legs, rectangles for the feet, and a triangle without the tip for the snout.

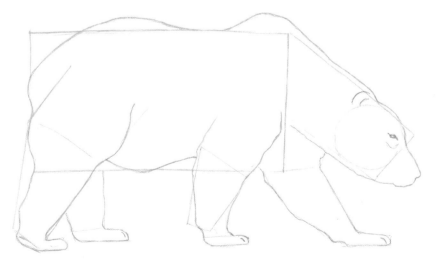

3 Using the above as a guide, draw the shape of the body. The snout will almost be the shape of the triangle, but we need to give it organic curves, as well as the details of the nose and mouth.

Draw the curves of the back where the legs push the shoulder blades and hips up. The belly hangs down. Round the edges of the feet. You may also want to add the eye at this point.

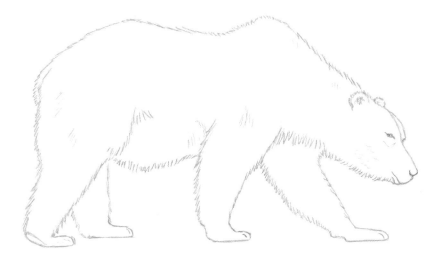

4 Erase the geometrical guidelines. Outline the figure with hairy strokes. Add the short tail and ears.

5 Begin shading by making short strokes in the direction the fur falls. Draw the mouth opening and the nose.

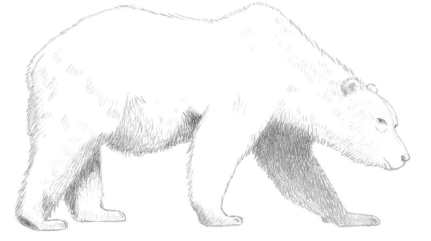

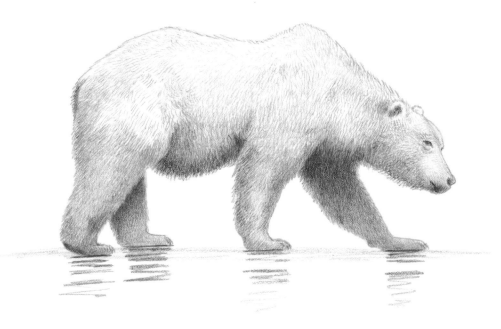

6 Continue drawing the fur with more short strokes. Apply light pressure for the light areas and more strength for shadows. Draw a ground line and then, if you want, some zigzag lines to give the illusion of a reflection.

Blocking Out

Another way of drawing, either from life or when copying from a photo reference, is to start with blocking out an "envelope," working from the broad to the specific.

Blocking Out an "Envelope"

Most of the figure will be inside the "envelope" when you block it out. However, it's okay if some small parts stick out.

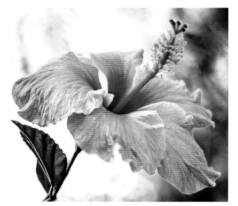

1 Visualize your subject's outline as if you had to enclose its shape with just a few lines.

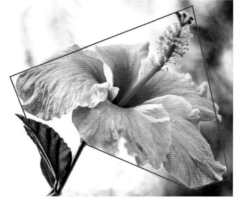

2 It may help to hold up your pencil to your subject to find the lines and angles. This is the "envelope."

3 Lightly sketch the shape and angles (they are shown heavier here for illustration only).

4 Start sketching your subject inside the larger shape, working from the broad to the specific.

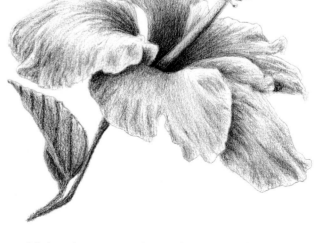

5 Add details, erasing the outline when finished.

Measuring

Artists usually measure using a pencil, though other tools can be used, such as sticks or calipers.

1 Hold the pencil vertically, and fully extend your arm, which keeps the pencil always at the same distance from your eye for consistent measurements. If you flex your elbow, the measuring tool will be closer to your eye, which changes the perceived dimensions of objects. Also, avoid rotating your shoulder. If needed, turn your whole torso from the pelvis. Close one eye, and place the tip of your pencil where you see the higher spot you're measuring (in this case, the tip of the swan's beak). Keep the other eye open, or no measurement will occur (joke)! Place your thumb on your pencil, at where you see the bottom point of what you are measuring (in this case, the bottom of the swan'ts neck). Make sure the pencil is parallel to your line of vision, because if it is tilted, it will distort the size.

2 Now you can transfer the measurement to your paper as you draw. You can do this if you're drawing at "sight-size," when the size of your drawing is the same as how you see it, or you can use that unit to compare or measure other things, such as how many heads fit on the whole length of the body.

Bigger Measurements First

The most important measurements are the bigger ones. If you have those correct, smaller ones are often easier to do.

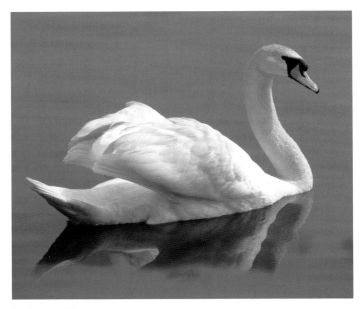

Reference Photo

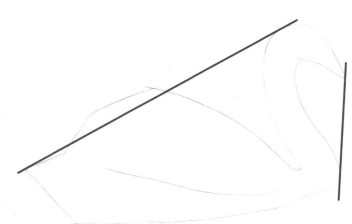

Angles

Angles

You can use angles as a reference from one "landmark" to another by finding the angle between the two, and duplicating it in your drawing.

Triangulation

If you've correctly placed two landmarks (such as the tip of the swan's beak and the bottom of its neck) and want to place a third one (like the top of its back), you can check the angle from one, and then from the other, to the new one, comparing the triangle shape to your subject or reference. If the two don't match, make corrections. Sometimes it is easier to detect a discrepancy by comparing shapes rather than lines.

Vertical Plumb Lines and Horizontal Lines

These are used in the same way as angles, but can often be more precise. For example, you could take an actual plumb line (a weight attached to the end of a string) and see what lines up visually, like "the eye aligns with the bottom of the back of the neck on a perfectly vertical line," as seen here. Vertical and horizontal lines are easy to visualize by using the top or bottom edge of your paper, or comparing objects to a horizon line. It is often just easier to visualize horizontal and vertical lines rather than angles.

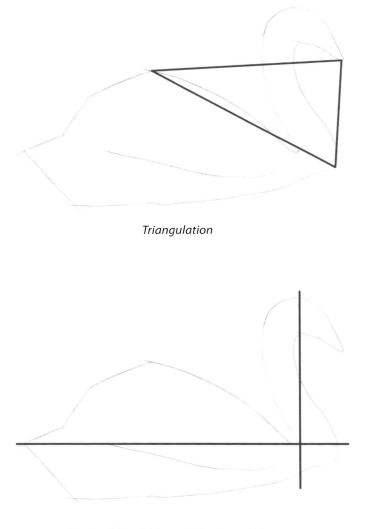

Triangulation

Vertical Plumb Line and Horizontal Line

Negative Space

Negative space is the area and shapes outside the main shape of a subject. If you can visualize the shape of the negative space, you can more easily and accurately draw the main subject. Understanding and using negative space visualization as a tool is instrumental for checking and confirming correct forms, or when drawing a somewhat complicated shape.

Putting It All Together

When making a drawing, you can use all the techniques in this chapter to make your work easier and more accurate. With practice, your spatial perception to gauge proportions and relationships will improve, and the use of the above tools will become second nature.

Trust Your Eye

Your eyes often work better than measurements. If your drawing looks wrong, it probably is. Check your measurements, and use other methods as needed. If you placed a body part by measuring, check the triangulation with other elements. With practice, you'll develop a better, more accurate eye.

To watch video tutorials related to this chapter, visit: www.fineart-tips.com/Chp5

Light and Shadow

Light and shadow create a three-dimensional effect, which is crucial for making a realistic drawing. It's magical when pigment on paper conjures up volume and makes a drawing come to life. This is achieved with values (lights and darks) that transition believably. As a general rule, you should have at least three values in your drawings: dark, middle, and light.

Anatomy of Light and Shadow

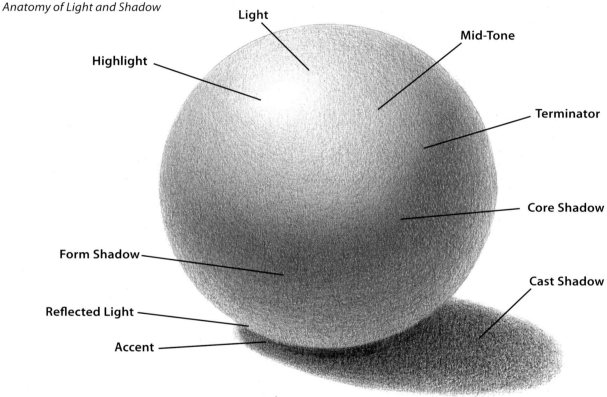

Light

Mid-Tone

Highlight

Terminator

Core Shadow

Form Shadow

Cast Shadow

Reflected Light

Accent

Areas of Light

There are different areas of light depending on where the light comes from, and whether it is direct or reflected.

Light Source
This is where the light shining on an object comes from. A soft, diffused light, such as on a cloudy day, makes soft, blurry shadows. A more intense, bold light source produces sharper shadows and more dramatic contrasts

between lights and darks. There may also be more than one light source.

Highlight
This is the brightest spot of reflected light on an object. Its location depends on the position of the light source, as well as the angle of the surface reflecting the light and where the viewer is. If you look at an object with a highlight, then move, the reflection seems to move too.

Light

These are areas where light rays hit an object more perpendicularly. As the surface curves away from the light, it tones down.

Mid-Tone

As the surface continues to face away from a light source, the actual tone of the object is perceived, unaffected by reflections or shadows.

Shadow Line (or Terminator)

The shadow line (or terminator) is the border where light transitions to shadow, at the edge where the light stops directly hitting the surface, just before the surface begins to face away from the light.

Reflected Light

When light is reflected onto an object from the surface it sits on, or another surface near it, it lightens the shadow. Shiny or white surfaces reflect the most light, while dark surfaces reflect the least. Two things with regard to reflected light:

1. It doesn't always exist, as not all surfaces reflect light back on to an object.

2. Don't get confused by the words *reflected light* and draw this area the same value as areas that are in the light. This is a mistake. Reflected light is an area in shade and should be darker than areas in the light.

Areas of Shadow

The two main types of shadows are the form shadow and the cast shadow. The form shadow is on the areas of the object itself that are turned away from the light (receiving no direct light). The cast shadow comes from an object blocking light from another surface.

Form Shadow

When a surface on an object curves or turns away from a light source, it catches no direct light. This form shadow is on the dark side of the object. Within the form shadow, there can be different degrees of darkness.

Core Shadow

This is the darkest area of the form shadow, located a step beyond the shadow line (or terminator). It's where the surface has the least light. The angle of the light source and any reflected light hitting the object will determine the thickness of the core shadow.

Cast Shadow

When an object gets in the way of light, it blocks the light from reaching what's behind it. Areas in this zone are called cast shadows. A bright light source projects a stronger cast shadow with a sharp edge, while a soft or

diffused light produces a dimmer cast shadow with a more blurry edge. Cast shadows should be darker than the shades on the object.

Accent

At the place where an object touches a surface (or another object), and the light is blocked, a dark area is created. This is the darkest spot of the cast shadow, called an accent.

It's Not Rocket Science

You do not have to figure all this out with mathematical precision. Just be aware that the area closest to the bottom edge of an object is usually less dark than the rest of the shadow area, and that in most cases with a rounded object, the darkest zone is a stripe along the surface within the shadow side, bordering the area of light.

Shading

There are many ways to shade.

Hatching and Crosshatching

You can make a series of parallel lines to give tone to a subject, called hatching. To make the area darker, you can make the lines thicker and closer. Or you may overlay lines in a different direction, called crosshatching. Hatching and crosshatching can be done with any drawing medium.

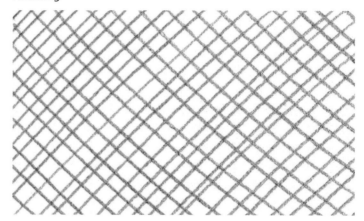

Hatching

Thicker Hatching

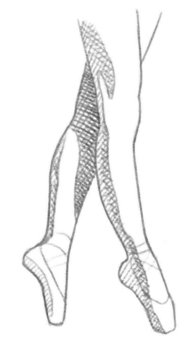

Crosshatching

1 A simple way to begin shading is by drawing lines to divide areas of light from shade.

2 Fill shaded areas with a light flat tone or hatching, as seen here.

3 Reinforce deeper shadows, as with the crosshatching here.

Shading with Circles

You can shade by overlapping other patterns such as tiny circular, oval, or doodle marks. I find this very effective. After doing a layer, you may do another layer on top of it, changing the direction of your strokes. This helps achieve a more uniform (and darker) finish. With practice, you will develop your own way of shading. Your shading will be unique to you, similar to what happens with each person's handwriting.

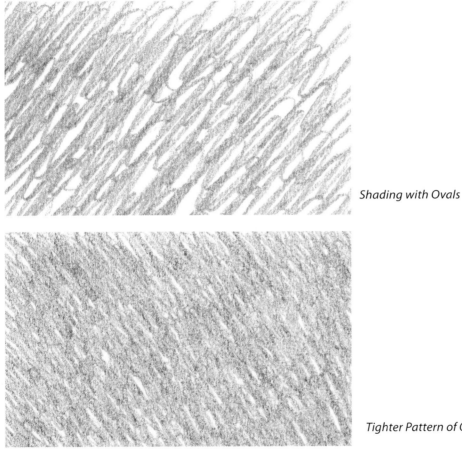

Shading with Ovals

Tighter Pattern of Ovals

Multiple Layers of Ovals

Smudging

You can smudge your shading with a chamois or brush, or for a smaller area, with a stump or tortillion. Instead of just smudging what is on the drawing, you can also tone by saturating your chamois, brush, stump, etc. with graphite or charcoal powder and applying the pigment to the paper that way. Please make tests on scrap paper before using it on the drawing, to make sure it gives the effect you are looking for.

Smudging with Different Media

Smudging is ideal for materials that have low adherence to the surface, such as charcoal. Many artists don't like smudging graphite because it can quickly become "muddy" and look dirty.

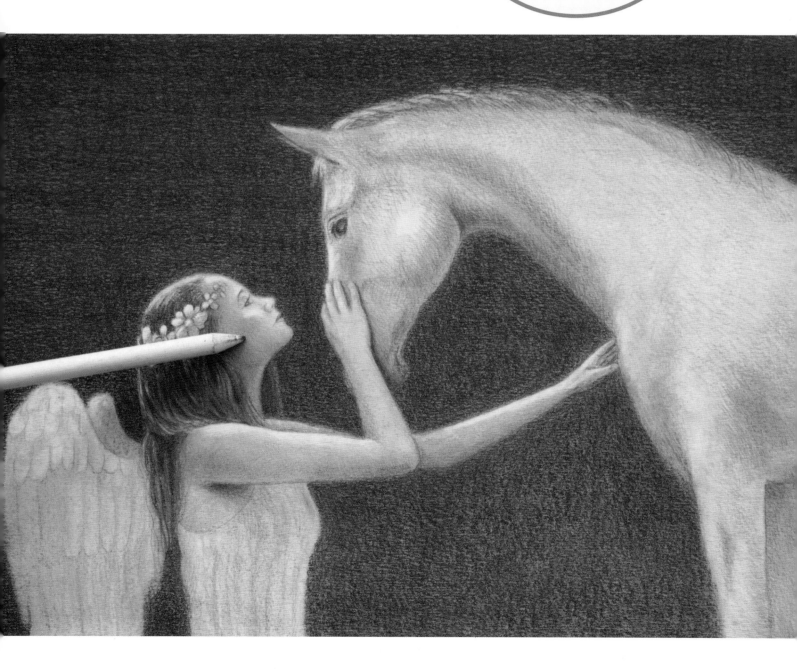

Toned Paper

When drawing on toned paper, you can use its tone as a middle value. By adding darks and lights, you can create appealing effects.

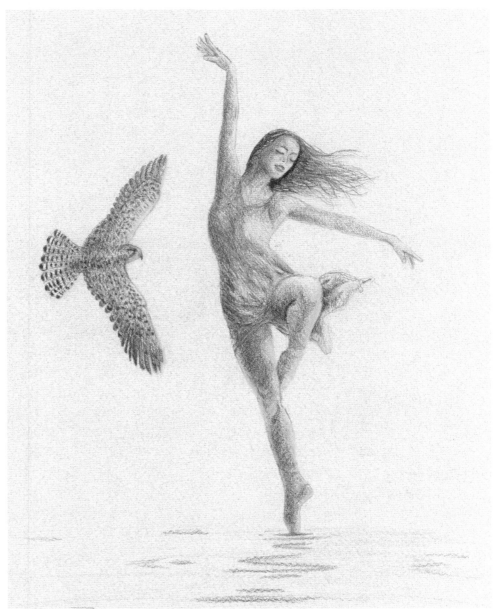

To watch video tutorials related to this chapter, visit: www.fineart-tips.com/Chp6

Still Life Projects

This chapter covers many of the basics you learned in earlier chapters with two detailed still-life demonstrations. Drawing still life is a great way to get started, because you may already have your subjects easily at hand, and it also gives you a strong foundation when you move on to other masterpieces.

DRAWING A BELL PEPPER

WHAT YOU NEED

- HB carbon pencil (you may use graphite or charcoal pencils)
- Kneaded eraser
- White drawing paper, about 11" x 17"

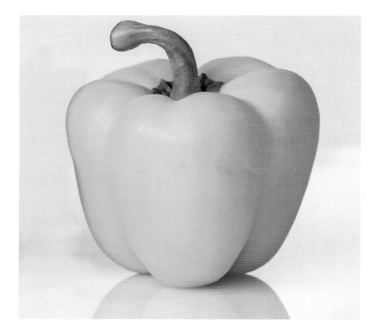

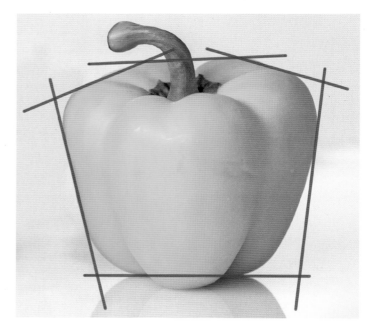

1 You can use this reference photo of a pepper, or follow the same techniques to draw from life if you have your own pepper handy. Observe it well. Look at the overall shape, at its contour and volume, at its tilt, if any, and at its contrast. Get a good mental image of what your final drawing will look like and what you have to do to accomplish that.

2 As you observe, visually block in the object by tracing imaginary lines around it (the red lines in the photo). Most of the object should be inside your enclosed area, or "envelope," but it is okay if once you enclose the main body, some small parts stick out (in this case, the stem and the part at the very bottom).

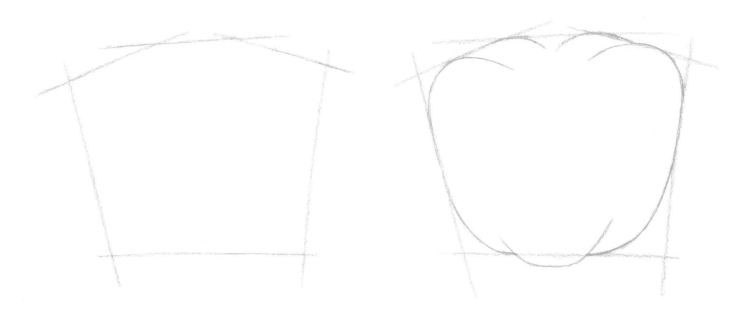

3 Draw the "envelope," which makes it easier to get proportions right, as well as to center the subject.

4 Using your "envelope" as a guide, draw the outline of the pepper. Most of the time I would have only done the outline itself, but in this case, I found it easier to draw the different parts if I continued some of the lines to make sure the upper and lower curves were in the correct place.

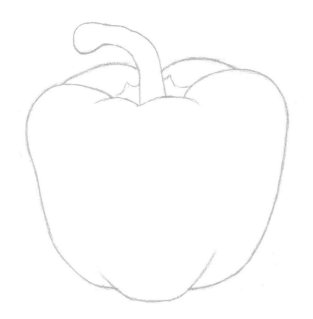

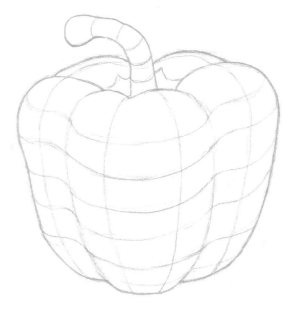

5 Add a few details of the stem and curves, using smooth, clean lines (not jagged). Once you have the outline, you can erase the "envelope."

6 Optional: Draw contour lines showing shape and volume. This is not absolutely necessary, but if you are learning and practicing, I recommend doing it, because it helps to visualize and understand the shape. Draw it with light lines so that they will not be in your way later (I did them darker here to demonstrate).

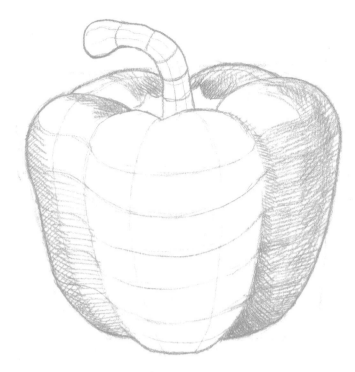

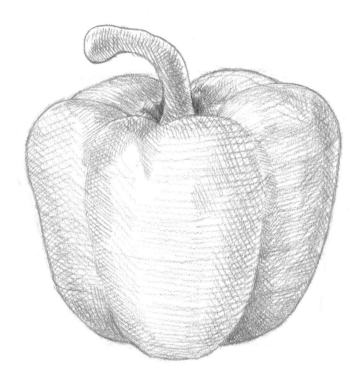

7 Observe your reference and begin shading. You can do this with short strokes that follow the volume of the object, and crosshatched lines in different directions to darken it. In this case, I started with the shading on the sides and top.

8 Complete your first layer of shading, observing and comparing it to the original. I saw that this looked pretty flat. More contrast was needed.

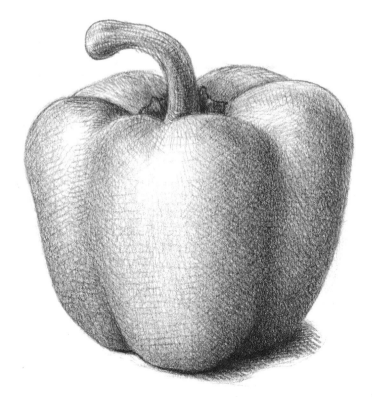

9 Reinforce the darker shades, such as the ones on the right and on the bottom, and if you like a more refined look, go over it again with more detail, using tighter lines in different directions. If you go too dark and need to lighten it up a little, you can make a flat area with your kneaded eraser, and tap the drawing gently a few times to pull up some of the medium.

A FALL STILL LIFE

WHAT YOU NEED

- 2B and 6B black carbon pencils
- Eraser
- White drawing paper, whatever size you prefer
- Additional vinyl sheet or blank paper to avoid smudging

1 Again, we have a photo reference, but you can use the same procedure to draw from life if you want to make your own arrangement. Visualize the "envelope" that contains your still life. Look at the overall shape of the arrangement (usually done with straight lines). In this case, I made the line that starts at far left go from the tip of the darker green leaf to the tip of the stem, to the tip of the maple leaf at top. This made it so that a small portion of the left leaf sticks out from the "envelope." It's okay to have a few little things outside the main shape. Also, I could have included the whole cast shadow in the envelope, or leave it out as I did.

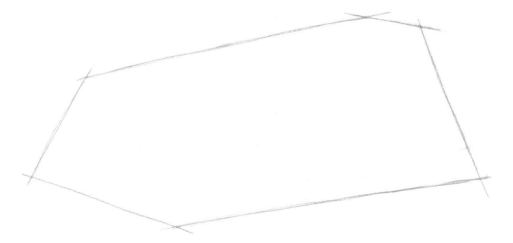

2 With the 2B pencil, draw the "envelope." You can transfer it to a smaller paper that is the same size as your reference photo; you can use paper that is large enough for your drawing to match the size of an arrangement in front of you; or you can make it larger or smaller, whatever proportion is most convenient for your situation.

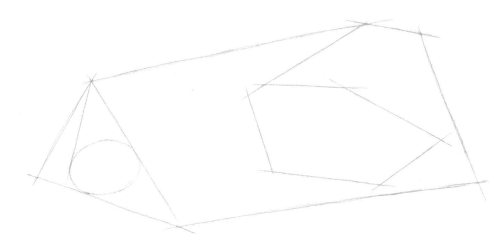

3 Visualize other key imaginary lines, and draw each on your paper—for example, the lines from the top of the left tangerine's stem to its sides, and each of the lines that enclose the fruits in the basket. It is essential that you look at the angles of these lines and that you draw them at the same angles to get correct proportions.

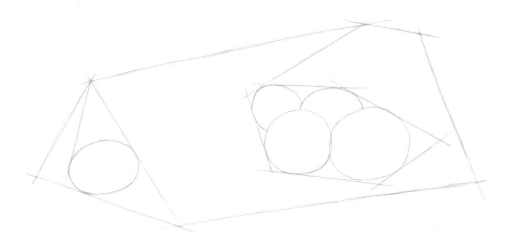

4 Begin drawing the shapes of the fruit. Double-check the size and shape of each one simply by looking at it in relation to the envelope and to the other objects to see if it all looks right. Make any corrections as needed.

5 Draw the depressions each piece of fruit has. Begin drawing their volume by indicating lines that go along the shapes as if they were slices.

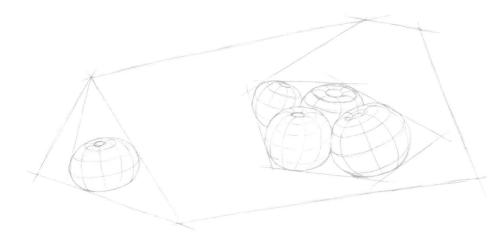

6 Optional: Complete making the lines that indicate the volume of each object. This is helpful to understand the shapes, but it is not always necessary.

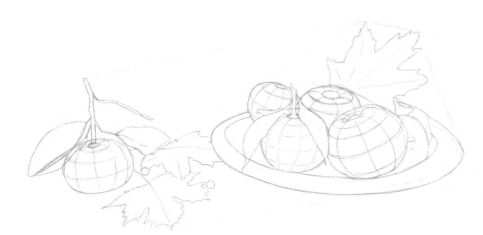

7 Draw the stems and leaves. At first, you can draw the general shape of each and then begin making the details. Also, sketch the small round fruits by the leaves between the tangerine and the fruit in the basket. Begin drawing the top of the basket.

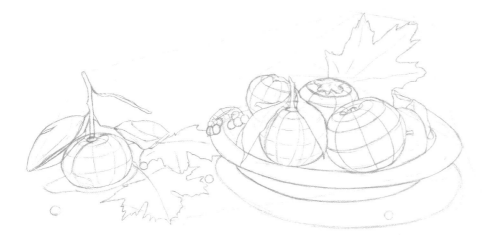

8 Draw the lower shape of the basket and its cast shadow. Draw the other little round fruits and leaves on the persimmons (the upper fruits at the back of the basket). Start to erase or lighten up your guidelines (such as the "envelope").

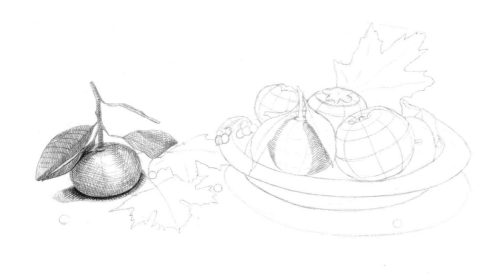

9 Begin shading the fruit on the left with hatching and crosshatching, following the shapes of the object. Do most of the shading with the 2B pencil and the darks with the 6B. At this point, I recommend using a vinyl sheet or blank paper under your hands to avoid smudging. It is also advisable to work left to right if you are right-handed (vice versa if left-handed) to avoid smudging the drawing with your working hand.

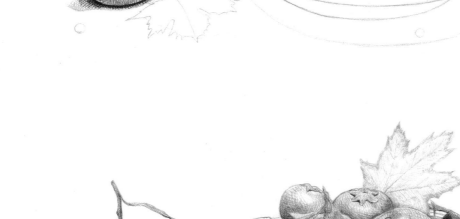

10 Shade the rest of the large fruits, as well as starting the dark shadow under them. If you want, you can also choose to contrast the tones a bit more than on the reference photo.

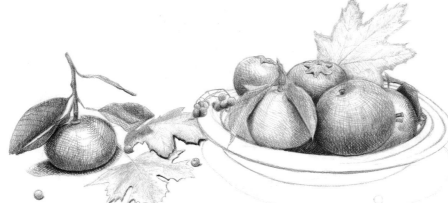

11 Draw the leaves with light hatching and crosshatching, as well as their cast shadows. Shade the small fruit, and add more lines to the basket. At this point, you might want to erase initial guidelines completely.

12 Start shading the basket. You can draw it without every little round hole and texture, or you can go for it, and try to render every little detail. Do it piece by piece, observing and copying small sections. Again, however, you don't have to draw every minute detail as it is, but give enough information to convey what it is. Also draw the shadow with the same style that you used for the basket (with more or less detail).

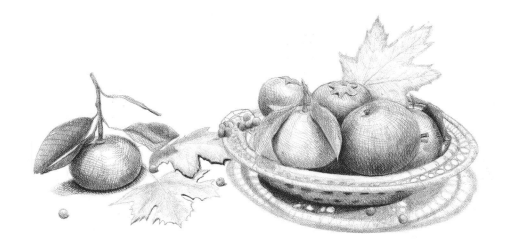

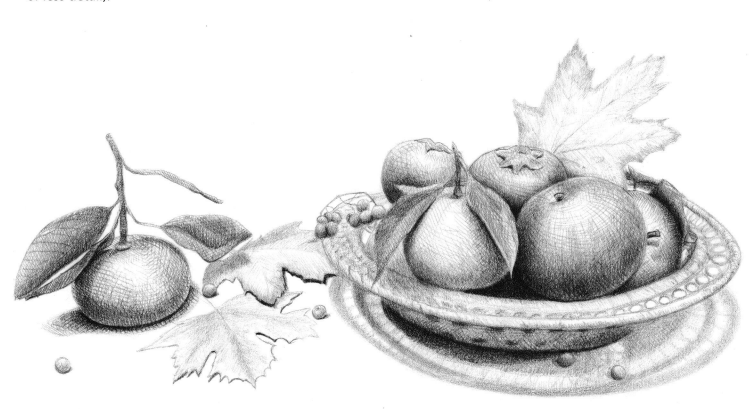

13 Step back and look at your drawing. See what can be improved, even if you depart from the reference photo. In this example, I delineated some shapes better, as well as making the lines of the basket and its shadow smoother. Be sure any visible guidelines, like the "envelope," are completely erased.

To watch video tutorials related to this chapter, visit: www.fineart-tips.com/Chp7

Composition

In the visual arts, composition is the arrangement of elements to produce aesthetic results—that is, to create desired effects such as attractiveness, beauty, and emotion. When viewers look at art, their vision moves from one element to the next. It normally goes to the most important thing first, the focal point. Then, the viewers' eyes may move on to other elements in the drawing. As an artist, you can plan and direct this eye movement. You can guide the viewer to the most important elements, and in most cases, you want the viewers' eyes to flow through the work, visiting other elements and coming back to the focal point. You can achieve this with artistic composition.

Rule of Emphasis

Every drawing you create should have a focal point where you want the viewers' attention to go first. The rest of the elements should not compete with the focal point, but should assist in directing the viewers' eyes to it.

Your focal point should contrast with its background, be sharp and in focus, and use leading lines that point to it. As a general rule, the more complex your composition is, the more elements you need to reinforce the focal point.

NO EMPHASIS
You don't know where to look with several subjects the same value.

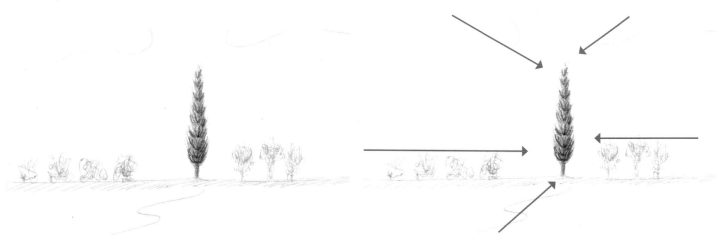

CREATING EMPHASIS WITH SIZE, SHAPE, AND VALUE
The cypress tree stands out because it's bigger, it's a unique shape, and it's darker than the rest.

CREATING EMPHASIS WITH LEADING LINES
Leading lines created by the shapes of the clouds, rows of trees, and line on the ground also guide attention.

CREATING EMPHASIS WITH COLOR
If you have vivid color in your drawing, make sure it's on your focal point, as it will draw attention.

CREATING EMPHASIS WITH CONTRAST AND SHARPNESS
The focal point stands out with more contrast and sharper detail than the rest of the drawing. It also creates an illusion of depth compared to the ship, which has less contrast and sharpness.

Rule of Thirds

Divide your paper into three equal sections both vertically and horizontally (like tic tac toe lines, seen here formed by the red lines and horizon).

Place your focal point on or near where the lines intersect or along them. This "rule" is easy to use, and the result is usually pleasing.

UNINTERESTING COMPOSITION
The boat and the horizon line are close to the middle, both vertically and horizontally.

MORE INTERESTING USING THE RULE OF THIRDS
The boat is reframed so that it falls over an intersection of the imaginary lines and the horizon, with the mast near a vertical line, and the horizon line a third of the way up the page. There is also some room in front of the boat (space for it to sail into). It looks freer, less tight, when you have empty space in front of the direction an object is moving in, or that a person's looking toward.

Symmetry

The Rule of Thirds is not really a rule, it is a guiding principle, and you can use it, ignore it, or modify it to better suit your subject. As seen here in this image, symmetry can work well for some subjects. In this case, it is best to drop the rule, and center your subject.

Balance

Each element in a drawing has visual weight, and balance is the distribution of that weight. Too much imbalance can look unnatural, but for some other subjects, when a drawing is perfectly symmetrically balanced, it may be a bit boring. Look for an interesting balance for your subject.

SYMMETRICAL BALANCE
Symmetrical balance can be good for some subjects, but a bit boring for others.

UNBALANCED VISUAL WEIGHTS
Too much imbalance can look out of place.

ASYMMETRICAL BALANCE
Achieving balance with two or more smaller objects counterbalancing a larger one is called asymmetrical balance.

BALANCE WITH POSITIONING
Another way to achieve balance is by having a larger object closer to the center and a smaller one farther away.

BALANCE WITH VALUE AND COLOR
An object with a darker value or with more vivid color has more visual weight than objects with less vivid colors.

TOO MUCH SYMMETRICAL BALANCE
This perfectly symmetrical composition is uninteresting,
and it looks a bit boring for this subject.

ASYMMETRICAL BALANCE IS MORE ENGAGING
Asymmetrical balance is better for this subject.

Framing the Scene

Whether you are drawing from life or from a reference photo, you can frame your subject in a way that is more interesting than it actually appears, or that conveys a feeling. You can choose the elements you want to include or leave out in a scene, and you can rearrange things. You don't have to settle for the position of every object in a scene as it actually is.

WAYS TO CREATE AN ADJUSTABLE FRAME
You can use your hands to create an adjustable frame, or cut two L shapes out of cardboard. Look through the created window and adjust the frame to find the best composition for your subject.

FRAMING WITH WHITE SPACE
Leaving breathing space on the side a person is looking at or in the direction an object is moving toward can make a scene feel natural and relaxed.

FILLING THE FRAME
A dramatic option is to fill the frame or most of the frame with the main subject. The result can be compelling.

Creating a Visual Path

You can create a "path" for your viewers' eyes to travel through your drawing. The eye usually goes to the main focal point first, then travels around the drawing to the other elements.

TOO MUCH BALANCE
An even number of elements, especially if it is two as seen here, may be boring for some subjects. The viewers' eyes can only go from one to the other.

A VISUAL PATH HOLDS INTEREST
With three or more elements, as seen here, you can create a visual path. The eye usually goes to the dominant element first (1), then it moves to the next one (2) and to the next one (3), before returning to the main element. As it continues to travel around the drawing, it holds the viewers' interest.

Consider Different Compositions

One "rule" might work best for one subject, while another might work best for another.
Try different arrangements to find the composition that you like best.

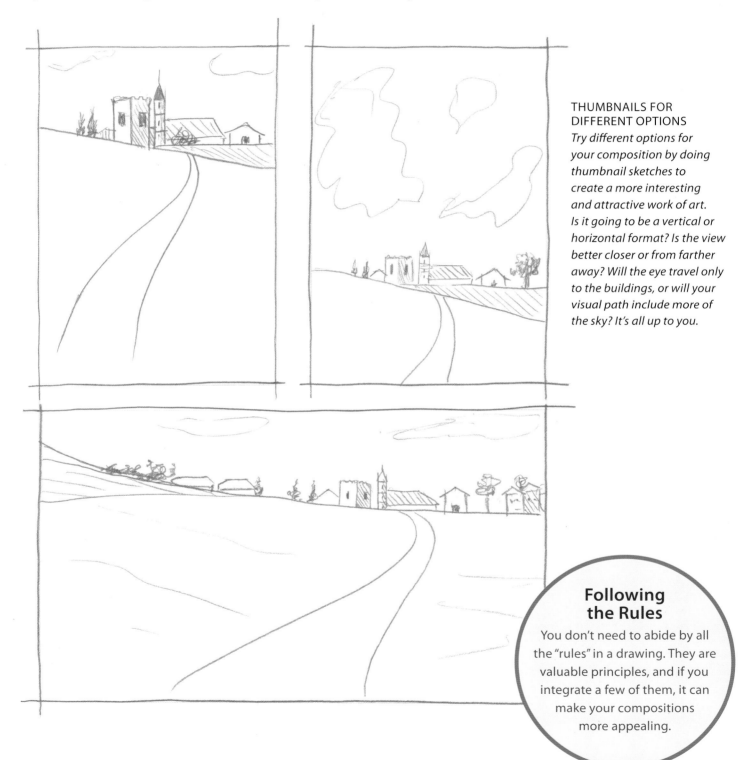

THUMBNAILS FOR DIFFERENT OPTIONS
Try different options for your composition by doing thumbnail sketches to create a more interesting and attractive work of art. Is it going to be a vertical or horizontal format? Is the view better closer or from farther away? Will the eye travel only to the buildings, or will your visual path include more of the sky? It's all up to you.

Following the Rules

You don't need to abide by all the "rules" in a drawing. They are valuable principles, and if you integrate a few of them, it can make your compositions more appealing.

WOMAN WITH GUITAR

WHAT YOU NEED

- Mechanical pencil with 0.3 2H, 0.5 HB, and 0.7 2B leads
- Kneaded eraser
- White drawing paper, about 11" x 17"
- Small pointed object (like a pin or screwdriver) for scraping
- Ruler

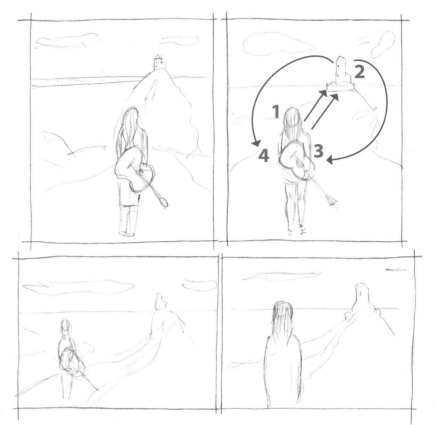

1 Make thumbnail sketches to work out the best composition. I chose the sketch at upper right. The woman, the lighthouse, and the horizon line all more or less follow the rule of thirds. Also, get a notion for how the viewers' eyes will move (I've indicated this with arrows), then add or delete elements to assist this.

2 You can measure your page and divide it into thirds, but I recommend making only small marks on the border of the paper, and not drawing the entire length of the lines on the page, since you can damage the paper when erasing them. With the HB lead, mark very light reference lines for the horizon, lighthouse, and woman. Simplify the basic shapes of the main objects, such as a box for the guitar and a couple of cylinders for the arm. I marked the size I want her to be, then drew guidelines for drawing her body, arms, legs, and guitar.

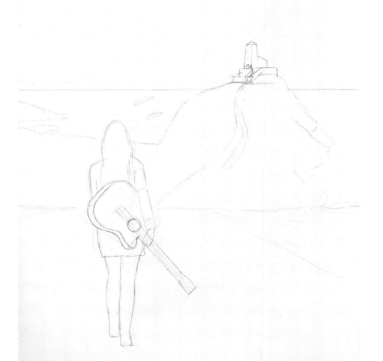

3 Based on the general shapes, draw the forms in more detail, like the roundness of the guitar. Also, sketch more and more elements of the landscape.

4 Once you're happy with the sketch, start shading, working mainly with hatching and crosshatching. Consider the light source as being toward the top left and slightly to the back; therefore, the shadows will fall to the right and down. Use the harder lead (2H) to give a tone to the sky by making short, straight lines. In some areas you can overlap them, making strokes in different directions to create darker values, leaving other areas lighter to create the effect of clouds. Also with the 2H lead, begin shading the lighthouse and the rocky hill.

5 Continue hatching and crosshatching down the hill, the path, and the rocks.

6 To the left of the woman's shoulder is an area of grass. Shade it with tiny, almost vertical lines. These lines should be in different directions, but all close to vertical. Then continue with the rocks that are toward the right. These take some patience, since each stone must be shaped and shaded individually. Just above the right elbow of the woman, there's an inlet of water that will be bright, so leave most of it white, especially on the right side.

7 Use the HB lead for the area closer to the viewer. Shade the rock that is on the left using straight lines in different directions, making it uneven, for a rough look. Use hatching and crosshatching for the road too, making vertical lines go toward a vanishing point on the horizon. We'll cover vanishing points more in the next chapter, but you don't need to work this out precisely; just direct the lines more or less toward a point on the horizon that would be above the middle of the road, so lines on the left will be slightly tilted to the right and lines on the right tilted to the left. The lines closer to the center of the road will be more vertical. Then cross them with short horizontal lines. Then add some rocks or spots so it is not all even. You can add more lines in different directions to darken further as needed. The area on the far right will have dirt, rocks, and some grass. Start adding some details to the woman.

To watch video tutorials related to this chapter visit: www.fineart-tips.com/Chp8

8 With the HB lead, draw the hair with flowing lines, leaving the sides and top white. Darken the background around her head. Shade the dress, adding texture, and the skin. Before shading the guitar, lightly indent six lines for strings with a pointed object (I used a tiny flat screwdriver with a ruler) from the guitar's bridge (the dark shape where the strings attach), across the sound hole, and along the fingerboard (the long skinny part). Lift your tool on the area of the hand, since you don't want strings there. When adding graphite,

these lines remain white (be sure your lead is fairly dulll, since a pointed lead will get into the indentations). Add details to the guitar, and refine its shape, drawing the darker parts with the softer 2B lead, as well as the boots. For drama, darken the right side of the sky, water, and parts of the hill as needed. For contrast between the land to the right of the road and rocks farther away, I darkened the land. Tapping with the kneaded eraser, I lightened the lower rocks, then darkened the bottom of the road to guide the viewer's eye up.

Perspective in Art

Perspective in drawing, and art in general, gives objects on a flat surface an illusion of three-dimensionality. There are two types of perspective. Linear perspective uses converging lines to represent the size of objects as they appear smaller as the distance from the viewer increases. Atmospheric (or aerial) perspective has to do with variations of value, color, and detail as the distance from the viewer increases. Both types of perspective are used to obtain the appearance of depth. It is of the utmost importance for an artist to understand perspective, because if it is not right, your drawings will look awkward.

Linear Perspective

The first step, if you want to draw with linear perspective, is to locate or establish the horizon line, which is the line found where the sky meets the land (or water). The location of this line will determine, to a certain degree, our point of view since it is generally at our eye level, and it will also determine the placement of the objects in the scene. The horizon line should be established from the start of a drawing, even when it is not actually visible.

A vanishing point is where parallel lines seem to converge on the horizon line. This imaginary point is very evident in the illustration of the railroad tracks shown here. Vanishing lines are the parallel lines that converge at the vanishing point.

VANISHING POINT
A vanishing point is where parallel lines converge on the horizon, as the tracks shown here do.

HORIZON LINE AND VANISHING POINT

The artist located the horizon line and the vanishing point to develop this rapid sketch done from life.

Edgardo Coghlan, *Horse Riding*, graphite, 6" x 6", Mexico.

With a Little Practice

With some practice and experience you will not have to necessarily draw all the lines to the vanishing points. Normally you will simply establish where the horizon line and vanishing points are and use them to develop your drawing.

One-Point Perspective

One-point perspective is the most basic form of linear perspective. It has one vanishing point, and it is used when an object has one plane (a side) facing us. If we intend to draw complex objects in perspective, we must first simplify them to basic shapes, and then we can build on them, keeping their correct angles and proportions.

CUBE IN ONE-POINT PERSPECTIVE

We're using a cube, although we can use this technique for any rectangular three-dimensional shape.

1 Draw the horizon line and vanishing point on it. Then draw the most frontal plane of the cube, which is a square.

2 Lightly sketch lines from each corner to the vanishing point (I'm using heavier lines for demonstration).

3 Make a line parallel to the base of the cube, between the vanishing lines. This will determine its depth.

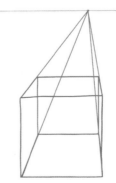

4 Draw two vertical lines from the ends of the line you drew in the last step, up to the vanishing lines.

5 Close the cube with a parallel line connecting the upper corners. (If this were to be a finished drawing, you would erase the vanishing lines behind the cube.)

Appearance of Objects in One-Point Perspective

When you can see the top of an object, it's below the eye level or horizon line, and its vanishing lines go up to the vanishing point. If you can see the bottom of it, it is floating above the horizon. It also makes a difference if the object is not level to the ground.

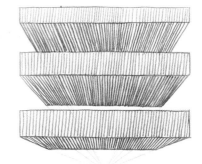

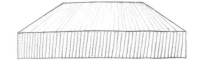

EYE LEVEL
Since the horizon line is at eye level, things above it are seen from below, and things below it are seen from above.

OBJECTS NOT PARALLEL TO THE GROUND
When stairs, streets, etc. aren't parallel to the ground but tilted up or down, their vanishing points may be above or below the horizon.

Edgardo Coghlan, *Cuetzalan, Puebla*, graphite, 14" x 10", Mexico.

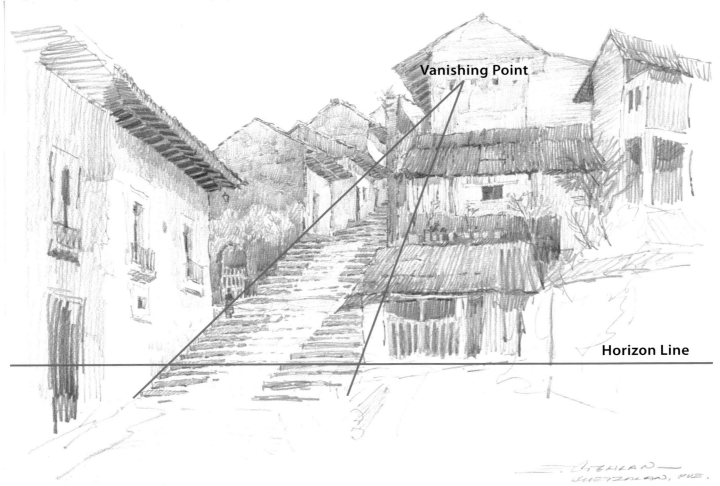

Vanishing Point

Horizon Line

Sizing Objects in One-Point Perspective

SUBJECTS LINED UP
It's easy to work out the correct size of people (or objects that are similar sizes to each other) if they are lined up behind each other. Simply project lines from the top and bottom of the first person (or object) to the vanishing point, and that will tell you the relative size of any others at any given distance. But what if we want to draw other people that are not aligned, for example, if they were standing on the red lines that are under the question marks?

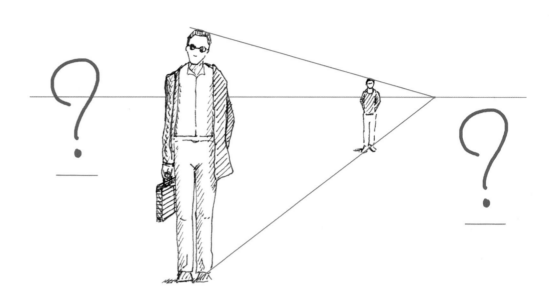

DETERMINING HEIGHT OF SUBJECTS NOT LINED UP
Draw a horizontal line from the point you want the person to be standing on to the lower vanishing line, as seen in the two lower horizontal lines here. From the point where the horizontal lines and the vanishing line meet, draw a vertical line up to the upper vanishing line. And from that point, make a horizontal line that goes back to the position you want your person to be, as seen in the two upper horizontal lines here. The distance from the lower horizontal line to the upper horizontal line determines the person's height in perspective. Once you have your subjects' correct heights in perspective, you can draw them.

Three Basic Rules of Perspective

1. Objects look smaller as they are further away.

2. The parallel lines of side planes will converge at the vanishing point.

3. Objects below the horizon line are seen from above, while objects above it are seen from below (since the horizon line is at eye level).

Two-Point Perspective

With two-point perspective, there are two vanishing points on the horizon line. This is a frequently used type of linear perspective, as the objects don't need to have one side facing the viewer, as in one-point perspective.

CUBE IN TWO-POINT PERSPECTIVE

1 Draw the horizon with two dots on it for vanishing points, one to the right and one to the left. With a vertical line, draw the front corner edge of the cube, which is closer to the viewer. Sketch lines from the top and bottom of the vertical line to each of the vanishing points.

2 Draw two side corner ends of the cube with vertical lines between the vanishing lines. If your vanishing points are an equal distance from the center of the cube, the sides would look the same. If one vanishing point is closer to the center of the page, the corresponding side of the cube would be smaller, as seen here.

3 Connect the upper and lower corners of each edge to the opposite vanishing points.

4 Go over the lines of the edges of the cube. If you are drawing a solid cube, you don't need to see the internal lines not visible, but you can draw a vertical line for the back edge of the cube for clarity.

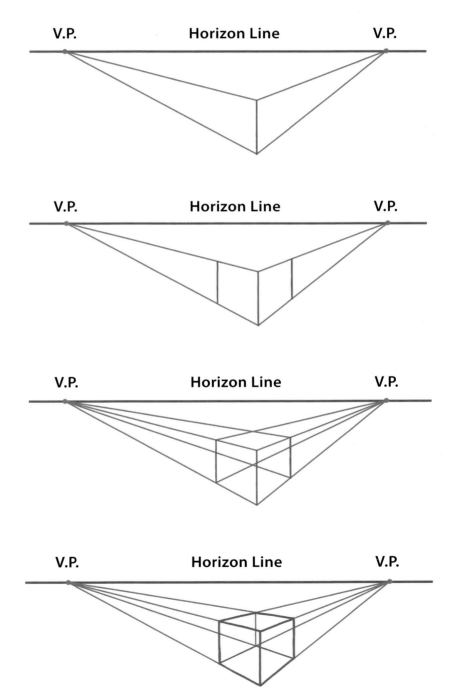

Appearances in Two-Point Perspective

If you are observing your subject from above, looking down on it, it's below the horizon line, and the vanishing lines extend up to the vanishing points. If your subject is at eye level, the vanishing lines converge at the vanishing points both upward and downward. If the subject is floating above you, the vanishing lines would converge downward.

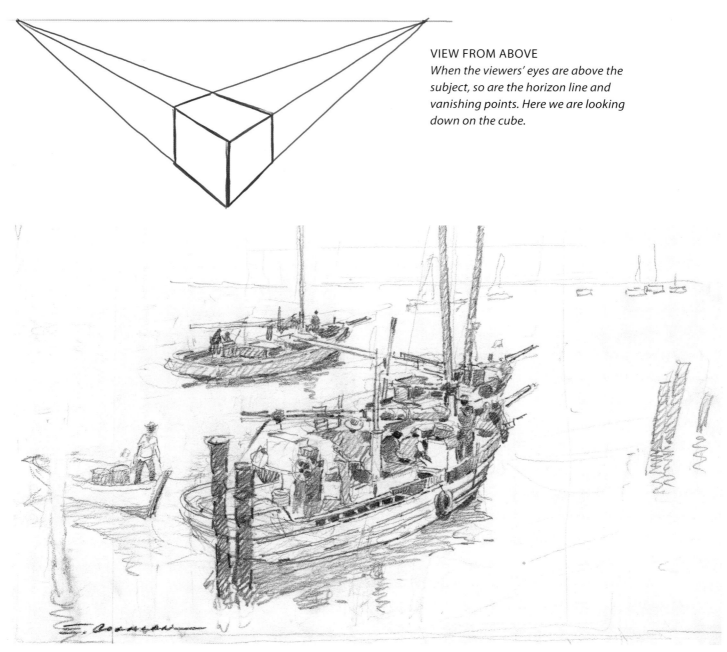

VIEW FROM ABOVE
When the viewers' eyes are above the subject, so are the horizon line and vanishing points. Here we are looking down on the cube.

BOATS SEEN FROM ABOVE
The horizon line is above the fishing boats, and the vanishing point for the main boat is at far right, perhaps even a bit out of the frame. The boats are seen from above, also called a bird's-eye view.

Edgardo Coghlan, *At the Dock*, graphite, 11" x 17", Mexico.

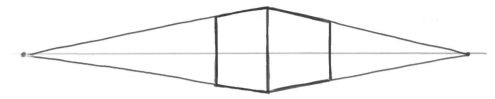

VIEW FROM THE MIDDLE
When the viewers' eyes are more even with the subject, so are the horizon line and vanishing points. Here we are looking at the cube from a midpoint.

Horizon Line

BOAT SEEN FROM THE MIDDLE
Here the horizon line is a bit lower, behind the boat, so we see more of the side, almost in profile.

Edgardo Coghlan, *Fishing Boat*, graphite, 11½" x 9½, Mexico.

VANISHING POINTS OFF THE PAGE
The vanishing points can be on your page, or they can be way to the side, out of the frame.

Fernando Pereznieto, graphite, 10" x 8", Guerrero, Mexico.

Roof

To draw a roof with an eave in two-point perspective, start with a cube, and then add the roof.

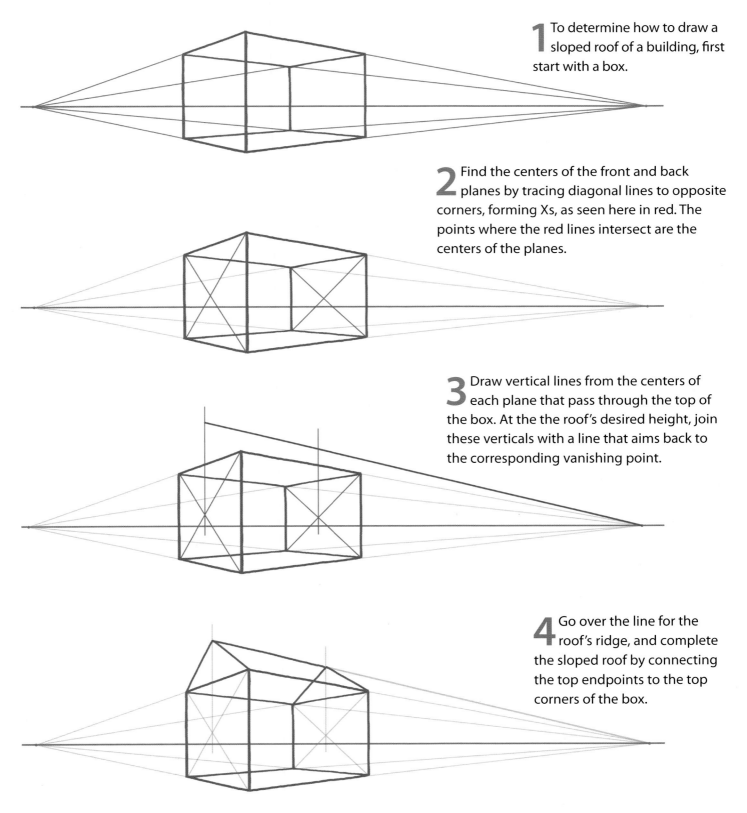

1 To determine how to draw a sloped roof of a building, first start with a box.

2 Find the centers of the front and back planes by tracing diagonal lines to opposite corners, forming Xs, as seen here in red. The points where the red lines intersect are the centers of the planes.

3 Draw vertical lines from the centers of each plane that pass through the top of the box. At the the roof's desired height, join these verticals with a line that aims back to the corresponding vanishing point.

4 Go over the line for the roof's ridge, and complete the sloped roof by connecting the top endpoints to the top corners of the box.

Arches

Single Arch

To draw a single arch, draw a rectangle in perspective. Find the center of the rectangle (intersection of red lines here). Sketch a vertical midpoint line to find the top of the arch above, and round the top at the desired height, once again using the vanishing lines for perspective.

MULTIPLE SHAPES IN PERSPECTIVE

You can use the following method to draw repeating shapes such as rectangles or arches in perspective. I will explain it with a straight-on view first, so you can more easily understand it.

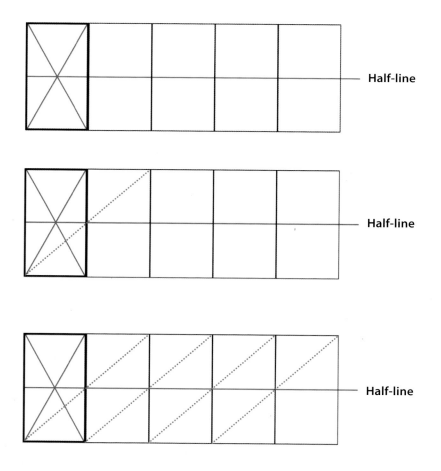

1 Find the center of the first rectangle by crossing lines to opposite corners. Draw a horizontal line that passes through the center point. This is the half-line for the whole set, while the top line is a vanishing line moving toward the horizon.

2 Draw a tilted line (the blue dotted line here) from the lower-left corner of the first rectangle, through the right side where it intersects with the half-line. Continue until it reaches the height of the original rectangle (on the top vanishing line), which will be the top-right corner of the second rectangle of the same size.

3 Repeat from the lower-left corner of each rectangle, passing though the half-line to the top vanishing line, as shown in the image. If we are always looking at these shapes straight on, as we are here, there is no need to go through all of that, since we could have just measured the first shape and copied it a few times. But this helps illustrate how it works when next viewed from an angle.

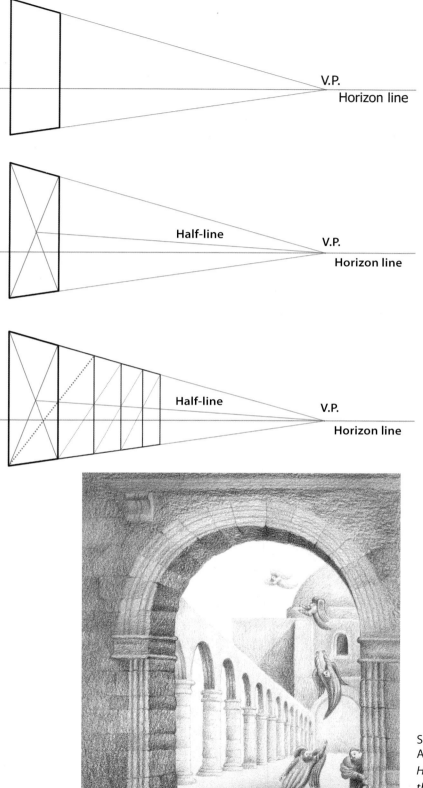

V.P.

Horizon line

Half-line

V.P.

Horizon line

Half-line

V.P.

Horizon line

4 Put it in perspective. Draw a vertical line at left for the first side of the rectangle. Lightly draw vanishing lines from its ends to the vanishing point on the horizon (in blue here). Make a vertical line within the vanishing lines for the right side of the rectangle. Complete the top and bottom lines of the rectangle as they merge toward the vanishing point.

5 Find the center of the rectangle by crossing diagonal lines to opposite corners. Then draw a line from the center of the X to the vanishing point. This will indicate the half-line for all the rectangles.

6 Sketch a tilted line (in blue here) from the bottom-left corner of the first rectangle through the half-line where it intersects the right side, continuing to the upper vanishing line. This point where the blue tilted line meets the top vanishing line is the top-right corner of the second rectangle. Draw its right edge down to the bottom vanishing line. Draw a tilted line from the bottom-left corner of the second rectangle though the half-line where it intersects the right side, continuing to the upper vanishing line. That point indicates the top-right corner of the third rectangle. Repeat for as many rectangles or arches as you want.

SINGLE ARCH WITH MULIPLE ARCHES IN BACKGROUND
Here we see a drawing where this system was put in practice.

Fernando Pereznieto, *The City of Angels,* graphite, 10" x 8".

Multiple Vanishing Points in Two-Point Perspective

The real world is full of different objects pointing in different directions, and there are often many other forms in a drawing besides the primary subject. Therefore, a scene could have multiple vanishing points depending on its complexity.

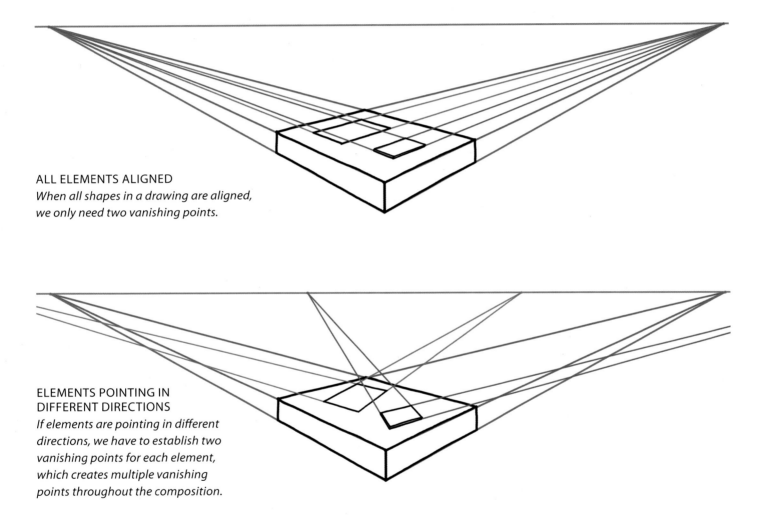

ALL ELEMENTS ALIGNED
When all shapes in a drawing are aligned, we only need two vanishing points.

ELEMENTS POINTING IN DIFFERENT DIRECTIONS
If elements are pointing in different directions, we have to establish two vanishing points for each element, which creates multiple vanishing points throughout the composition.

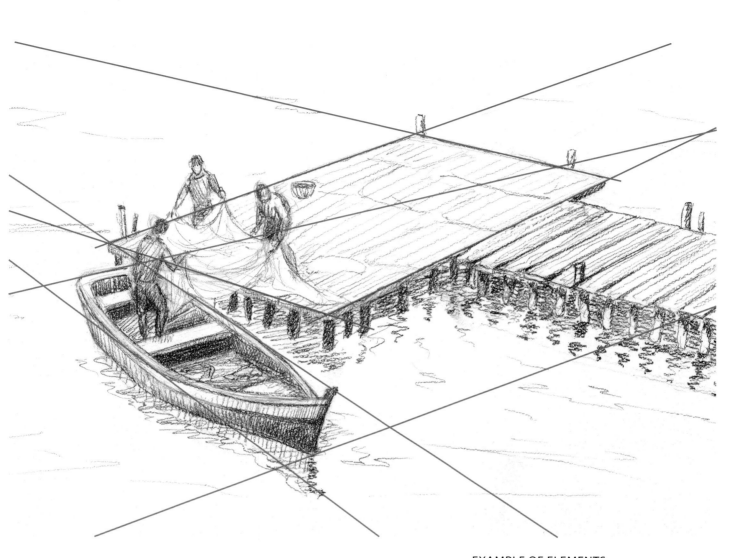

EXAMPLE OF ELEMENTS
IN DIFFERENT DIRECTIONS
The fishing boat is at an angle to the dock.
Therefore, the boat and the dock each need
their own sets of vanishing points.

Three-Point Perspective

When objects are far above or below the viewer, we should employ three-point perspective. One- and two-point perspective are commonly used; however, they are a simplification. In reality, when we look at vertical lines, let's say looking up at a tall building, we don't see them perfectly vertically. They are slightly tilted toward a vanishing point that is high up. The only vertical lines that actually appear vertical are directly in front of us.

TALL BUILDING SEEN FROM ABOVE

Three-point perspective can be of great help when drawing objects that are far above or far below us. In this example, we will draw a tall building seen from above. Here we have a bird's-eye view.

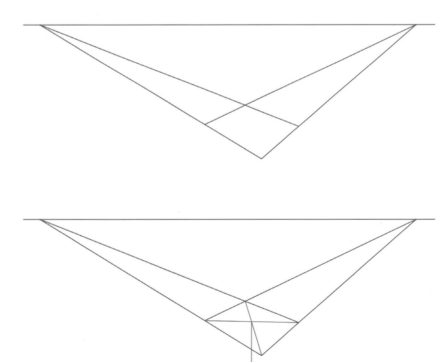

1 Begin making a rectangle, as with two-point perspective, for the top of the roof.

2 Find its center by drawing intersecting lines from the corners of the the rectangle.

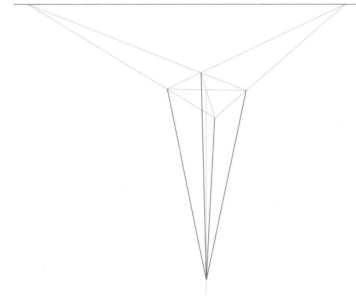

3 Draw a vertical line straight down from the center of the rectangle. Mark the third vanishing point, which will be on that line. Connect all four corners of the rectangle to the third vanishing point.

4 Draw the base of the building at the desired height using two-point perspective.

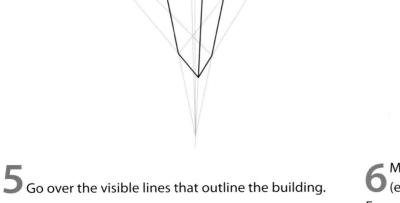

5 Go over the visible lines that outline the building.

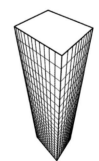

6 Make lines to simulate the exterior of the building (every one of these lines points to a vanishing point). Erase the vanishing lines.

CITYSCAPE SEEN FROM ABOVE

Of course, three-point perspective can be used for multiple objects sharing the three vanishing points.

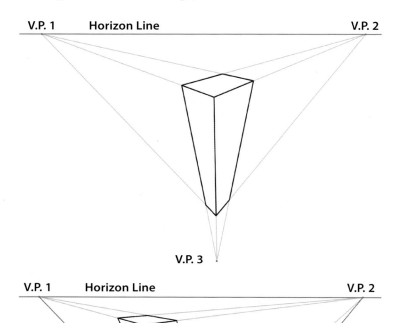

1 As in the prior example, begin by making a rectangle for the top of the roof of the building using the two vanishing points on the horizon line. Then connect the edges of the rectangle with the third vanishing point, which will be below the building. Draw the base of the building at the desired height using V.P. 1 and V.P. 2.

2 Using the same three vanishing points, repeat the above steps to lay out another building, which can be of the same or of a different height than the first one. In this example, the building to the left is slightly taller than the original one.

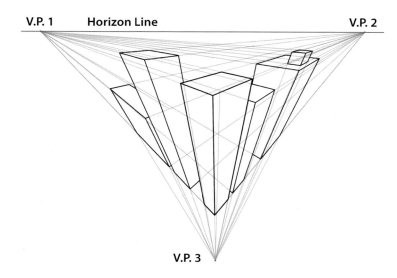

3 Repeat the above procedure to draw as many buildings as you like. Although each individual building can be taller or shorter than the one next to it, as they get further away, they should appear smaller and smaller as they approach a vanishing point, as indicated by the blue vanishing lines.

4 At his point, you can erase the vanishing lines, and shade the buildings so they look solid.

V.P. 1 **Horizon Line** **V.P. 2**

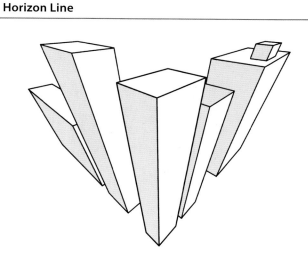

V.P. 3

In the previous example, the third vanishing point is very close to the buildings, which makes the perspective more intense (more exaggerated). If the third vanishing point is more distant, the effect is softer (the vertical lines appear to be more parallel), as in this example.

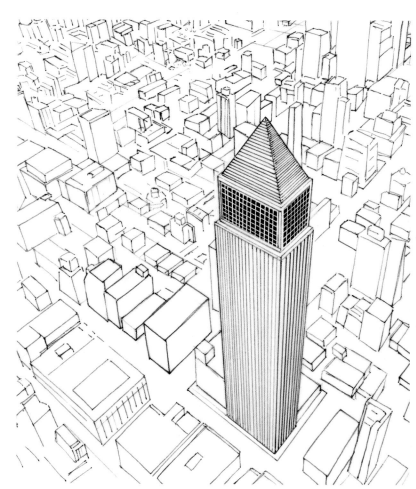

Linear Perspective Projects

Here are two projects to practice linear perspective. The first is reasonably simple, while the second is more complex.

LITTLE CASTLE IN TWO-POINT PERSPECTIVE

For this project, I used a mechanical pencil, but you can use any drawing pencils with the recommended leads. And although I drew all the lines freehand, I also used a square ruler to check vertical lines as needed. I recommend drawing freehand as much as possible, but you can use a ruler if you need to.

WHAT YOU NEED
- Pencils with 2H, HB, and 2B leads
- Kneaded eraser
- Vinyl eraser
- White fine-grain drawing paper, about 11" x 16"
- Optional: Medium-size square ruler

1 Before beginning your drawing, work out the composition (especially the position and size of the main subject). Establish the location of the horizon line and the vanishing points even when they are not visible. A quick thumbnail is very useful for this.

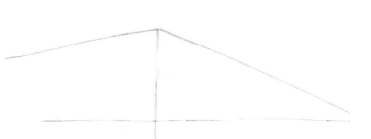

2 Using a 2H lead, mark the vertical line for the corner of the castle closest to the viewer, then lightly draw the horizon line. Locate the two vanishing points, one to the right just past the border of the paper, while the other one will be about 8 or 9 inches to the left of the page.

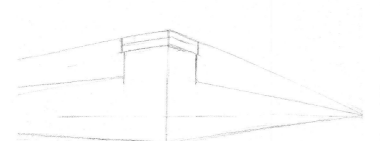

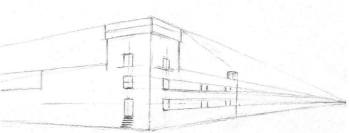

3 Sketch the verticle lines of the tower, then its top, as well as the top and bottom of the walls, pointing the horizontal lines toward each vanishing point.

4 Using the vanishing points, sketch the positions of the window openings. You can start adding detail, such as the entrance to a turret, etc.

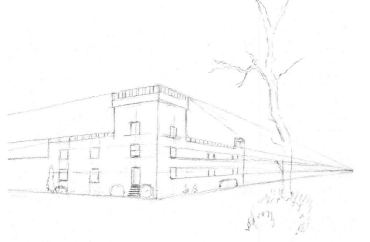

5 Complete the basic sketch by adding the window openings on the left, the battlements on the top of the tower and along the top of the walls, and some trees and bushes.

6 The light source is at top right. Using the HB lead, begin shading the building with short strokes. To give the illusion of stone blocks, you can use horizontal and vertical motions. The horizontal ones should be directed toward the corresponding vanishing point.

7 With the 2H lead, shade the right side of the castle. Fill the dark window openings with the 2B lead. Draw the bushes with the HB lead using loose, scribbling motions, darkening the areas on the left and the bottom.

8 Using the HB pencil with loose movements, draw the grass. Then, with the 2B lead, shade the tree trunk (don't make it too smooth, leave it a bit rough). Draw the leaves with scribbling movements.

9 With the HB lead, draw the cast shadow of the tree, the bushes, and the castle, with all shadows going in the same direction. With the 2H lead, draw the sky with straight lines, lightly hatching. Leave some areas white for the clouds.

STREET VIEW WITH MULTIPLE VANISHING POINTS

As in the last project, I drew all the lines for this project freehand, but used a square ruler to check vertical lines as needed.

WHAT YOU NEED

- Mechanical pencil with HB 0.5mm lead
- Black fine liner pen, 0.3mm
- Pigment markers, light and dark gray
- Non-bleeding paper, 9" x 12"

Elements Aren't Always Parallel

When elements such as buildings and streets aren't parallel to each other in a scene, or don't fall in straight lines, they may need different vanishing points.

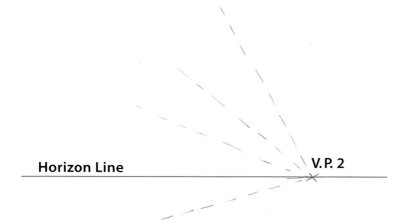

Horizon Line **V.P. 2**

1 Establish the horizon line and two vanishing points (we will later use an additional one). V.P.1 will be about 2 or 3 feet to the left of the paper, and will be used for the horizontal lines of the rooftops, windows, and curb at the left of the drawing later. Draw V.P.2 on the horizon line as shown. From it, draw vanishing lines to key points as guidelines for the rooftops, windows, bottoms of buildings, etc.

2 Guided by the vanishing lines, draw the tops and bottoms of the roofs, as well as basic lines for the windows and bottoms of the buildings.

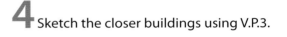

3 V.P.2 was suitable for the houses far away, but I don't want them all in a straight line, and therefore, I added V.P.3 slightly to the left of the other one. We will point the parallel lines from the nearby walls to V.P.2 or V.P.3.

4 Sketch the closer buildings using V.P.3.

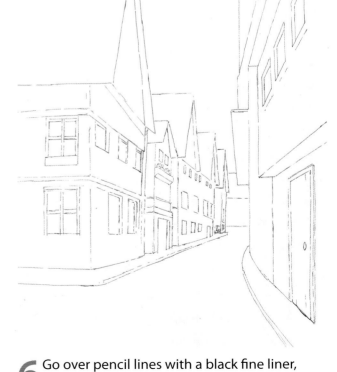

5 Build detail for the windows and entrances.

6 Go over pencil lines with a black fine liner, such as a 0.3mm.

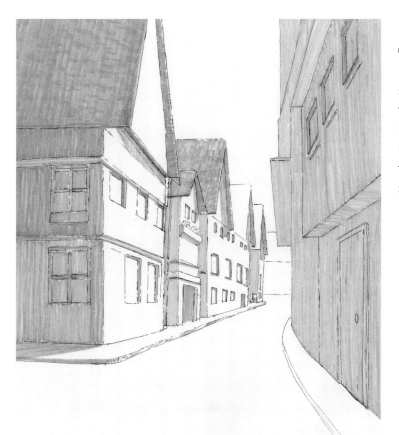

7 The light source is toward the top right. Using your lightest gray pigment marker, shade the planes of the buildings that face toward us and toward the bottom, leaving what is facing to the right in sunlight. In this case, I used straight vertical lines for shading almost throughout, but did the roofs with additional short lines to create the texture of the tiles.

8 To intensify some of the shadows (such as the shaded walls closer to us on either side of the road), go over them once more with the same light marker. This time, make the strokes in a different direction, using the vanishing points as guides. Draw the cast shadow of the building on the street with short strokes. With your darker gray marker, draw accents, such as the shadows of the window frames, the entrance opening, the nearby windows in shadow, and some shades of the tree.

9 Darken the closer buildings by going over them once more with the light gray. Go back and add texture on the building walls. With your dark gray marker, draw shadows under the windows and roofs. Then with the fine liner, you can draw some details like the people walking and the plants on the window, to which I also added some dark gray. Congratulations. You are done!

Atmospheric Perspective

Atmospheric (or aerial) perspective is the optical phenomenon that changes the way objects look depending on their distance from the viewer. When we have a lot of atmosphere (distance) in between the viewer and an object, it affects how the object looks. We can use atmospheric perspective to create the illusion of depth together with linear perspective. There are basically four ways in which atmospheric perspective affects how we see faraway objects.

Color Saturation Decreases

We see more vibrant colors on close objects, but as distance increases, with more atmosphere between the viewer and the objects, color saturation decreases. Objects look paler, cooler, and bluer, since the atmosphere appears as bluish gray.

Contrast of Values Decreases

The contrast between darks and lights decreases with distance, with no complete blacks or whites far away.

Overall Value Lightens

Values also appear lighter with distance. A mountain range far away appears lighter than the foreground.

Detail Diminishes

Atmosphere between the viewer and objects also makes it harder to see details. We may see sharp edges on nearby objects, but with distance, edges appear to soften. This can change with different circumstances, such as thick fog, low light, etc.

ATMOSPHERE CHANGES VALUE AND DETAIL
With atmospheric perspective, far away objects appear lighter and with less detail because of the atmosphere.

Edgardo Coghlan, *Huahuaxtla, Puebla*, 1977, graphite, 13" x 11½", Mexico.

LANDSCAPE WITH HILLS

We will make a sketch with hills and a small castle that shows depth.

WHAT YOU NEED

- Drawing pencils, HB, F, 4B, 3H, and 2H
- Pencil sharpener
- Kneaded eraser
- White drawing paper, about 8½" x 11"

1 With the HB pencil, sketch slanted lines to define the hills. The farther away they are, the lighter you should draw them. With the F pencil, draw a couple of small houses, then a fortress with a tower as shown, and a few trees, all on the second hill. We will consider the light source as being on the top left.

2 With a flat area of the 4B lead, loosely draw pine trees and bushes on the first hill nearest the viewer. The right side of the objects should be darker because the light is coming from the left.

3 Continue on the first hill, drawing different types of trees, as well as repeating some, until completed. With the HB pencil, give some tone to the buildings and the upper part of the second hill, lightening the value a bit as you come down.

4 With the HB pencil (not too sharp), give a tone to the second hill, matching the value of the buildings on the upper part, and lightening it up as you come down using an F or a 2H pencil as needed.

5 With a 2H pencil, lightly draw a hill behind the one with the buildings, again giving it a tone and lightening it up as you come down. Then, with the 3H pencil, add an even farther and lighter elevation.

6 With loose, simple strokes, shade the sky, leaving some areas white for the clouds. Review your drawing and do any fine-tuning.

To watch video tutorials related to this chapter, visit: www.fineart-tips.com/Chp9

CHAPTER 10
Drawing Textures

You can create many realistic textures with graphite. I used the same materials for the following projects to create different effects. I used a mechanical pencil, but you can use other types with the same leads.

CRYSTAL APPLE

When drawing transparent objects, keep in mind that when light hits the surface, it usually creates a sharp, small reflection, and then the light beams go through the object, illuminating the opposite side. Often the shading is "backward" in that the darker side is the one facing the light, and the opposite side gets more illumination. In this case, we will have two light sources, the strongest coming from the top left, and another one coming from the top right.

WHAT YOU NEED

- Pencils with 2H, HB, and 2B leads
- Kneaded eraser
- Pen-style eraser, round tip
- White fine-grain drawing paper, 80-90 lb, about 8½" x 11"

Sharp and Smart

To minimize interruptions, have several pencils of the same type, and sharpen them all before you start drawing. That way, when a pencil needs sharpening, you can just put it aside and pick up a sharp one.

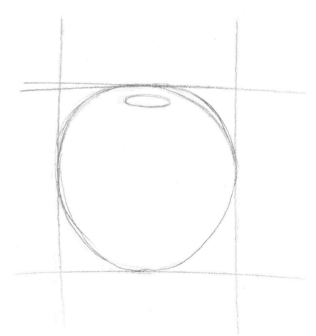

1 Using the 2H lead, sketch two vertical and two horizontal lines the height and width of the apple. Then make the shape of the apple with an oval inside those lines, slightly thinner at the bottom than the top, and make a small, horizontal oval on the upper part to indicate the depression at the top of the apple.

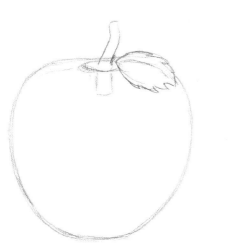

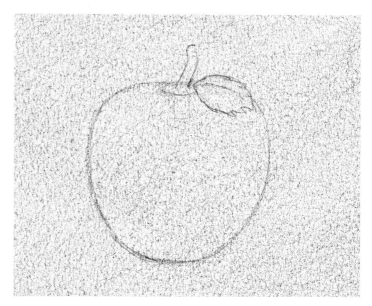

2 With the HB lead, refine the shape and lines. Then sketch the stem (which goes all the way inside the apple) and the leaf. Erase the guidelines.

3 Draw a general overall tone. You can do this by lightly making a pattern of straight lines in a fairly even layer, a second layer in an opposite direction, and a third layer in another direction. That should even it out. This will be the general tone for the apple, as well as for the background.

4 With the kneaded eraser, pull some lights: an intense small one at upper left, a larger one (also intense) at lower right, and another one at lower left. Then erase a reflection on the ground.

5 With a sharp 2H lead, darken the tones of the apple, especially toward the upper left and bottom. Tap with the kneaded eraser (and then as needed with the harder pen-style eraser) to make some scattered small circles for the bubbles. Lightly outline them with pencil, and then shade the inside of each. On the right side of the apple, make a light reflection with the eraser. Deepen cast shadows around the stem and leaf.

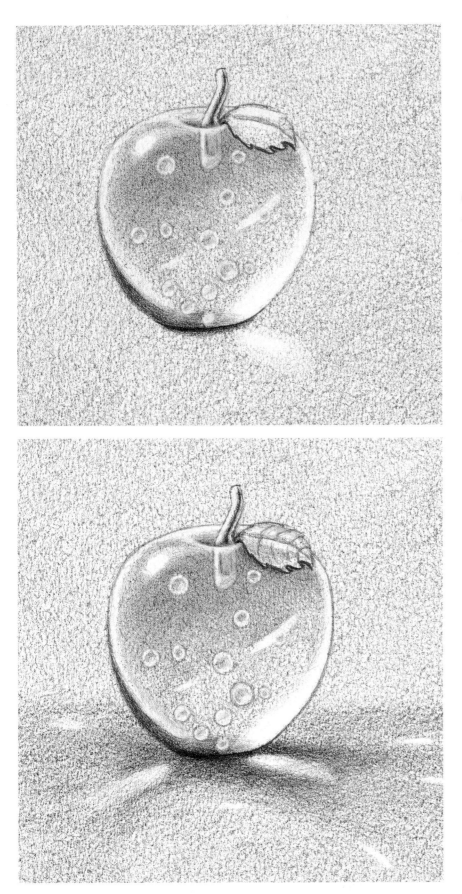

6 With the HB lead, make a darker shadow along the lower left side. Then refine the shading, the shapes of the reflections, etc. I made another light reflection to continue the line of the one that goes across the apple.

7 Pull light reflections on the surface where the apple sits. To make it appear grounded, darken the background around the bottom of the apple, then darken it even more underneath the apple (leaving the light reflections) using an HB or a 2B lead.

ROCK

This rock is hard and rough. Even though we're using fine-grain paper, we're going to use that grain to our advantage. Note that using a sharp lead point for shading can fill the whole surface of the paper where you draw, showing very little of its grain, while a flat area, especially on the side of the lead when you tilt the pencil, can show the grain better.

WHAT YOU NEED

- Pencils with HB and 2B leads
- Eraser
- White fine-grain drawing paper, 80-90 lb, about 8 ½" x 11"

1 Using straight lines with an HB lead, block in the shape of the rock and its planes.

2 Draw the shape of the cast shadow. Begin shading the shadows as shown. The light source is above the rock, slightly to the right and behind it. We want the texture of the paper to show, so if your lead is not flat, get a flat section by rubbing it on a scrap of paper.

3 Shade the other areas, with the darkest areas toward the bottom and left, and the lightest to the upper right. I shortened the right side of the rock slightly, because it was too long and looked like a turtle's head!

4 Further reinforce some of the dark areas with the HB or 2B lead. Give tone to the lighter areas by applying a little less pressure with the HB lead, then finish the cast shadow.

A SILVER RING

Shiny, reflective metals have a lot of high-contrast reflections.

WHAT YOU NEED

- Pencils with HB, 2B, and 2H leads
- Eraser
- White fine-grain drawing paper, 80-90 lb, about 8½" x 11"

1 Using the HB lead, draw an axis line for the oval, and reference lines to indicate size. Sketch an oval for the outside of the ring between the reference lines, using the axis line for the ends. Add an oval inside the first one for the inside of the ring, as well as adjacent lines to indicate its thickness. At first your lines will not be pretty, but you can clean them up with an eraser. Try to maintain an even, smooth line.

2 Make another axis line parallel to the two others as a guideline to draw the heart. Modify the ring to create the heart, erasing unnecessary lines as you go.

3 With the 2B lead, draw the dark reflections, the wavy lines across the heart, as well as stripes and shapes on the sides. Then, with the 2H lead, draw a fairly even tone on the bottom side of the ring. You can do this with short, light lines.

4 Shade the heart with light lines, leaving white reflections on either side of the dark wavy line. Also shade sections of the sides, leaving some spaces blank to represent light reflections. Finally, draw a shadow below the ring that blurs toward the ends, with an upside-down U shape.

WOOD

Wood can come in many different patterns and tones. It has a warm feel to it.

WHAT YOU NEED

- Pencils with HB and 2H leads
- White fine-grain drawing paper, 80-90 lb, about 8½" x 11"

Have Fun with It!

Drawing realistic wood-grain textures for fences, doors, and other elements in a scene is very simple. All is takes is some lines and shading. Patterns often don't need to be exact, so have fun with this!

1 With the HB lead, make evenly spaced vertical parallel lines for three boards. Draw a dark knot toward the lower left of the first board. Start making lines along the left edge. When you get close to the knot, the lines will be affected by it. Wood grain behaves similar to water. It will avoid the knots, flowing around them in patterns and waves. You can also start to play with patterns of wood grain.

2 Continue making the lines, playing with them, flowing from top to bottom. Avoid making perfectly straight lines.

3 Draw the other two boards with the same idea. I left the middle board more even, while adding more knots and waves to the one at right. When you are done, so that the blank spaces are not totally white, go over the whole drawing lightly with a 2H lead.

To watch video tutorials related to this chapter, visit: www.fineart-tips.com/Chp10

Drawing People

Some say bodies and faces are the most difficult subjects to draw. In this book, I want to give you some useful guidelines and tips that will make it easier for you.

The Head

If you measure the head from the top of the skull (not the hair) to the bottom of the chin, the eyes are about halfway. If instead of the whole head, you take the face from hairline to the bottom of the chin, and divide it into thirds, you will find key landmarks:

a. The top third goes from hairline to eyebrows, which roughly lines up with the tops of the ears.

b. The second third goes from eyebrows to the bottom of the nose, which roughly lines up with the lower parts of the ears.

c. The last third goes from bottom of the nose to the bottom of the chin, with the mouth opening roughly in the middle of this last third.

In profile, we find the same landmarks.

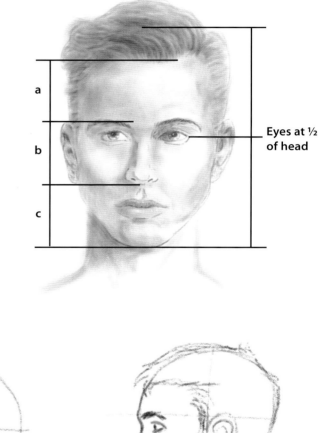

Eyes at ½ of head

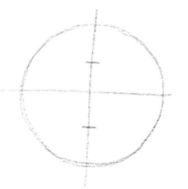

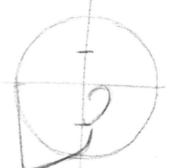

Head in Profile

1 Draw a circle. Divide it in half vertically and horizontally with two lines. The horizontal line is the height of the eyebrows and top of the ear.

2 The ear is right of the vertical line and below the horizontal one. Make a straight line from the intersection of the circle and horizontal line for the front of the face, extending the chin lower than the bottom of the circle, and angling up to the earlobe for the jaw.

3 Draw the other features with this framework.

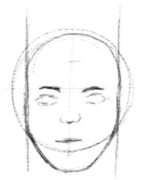
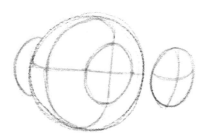

Rotating the Head

Viewed from the front, since the head isn't a round balloon, you can take off slices from either side of the circle or sphere, and just use ovals for the ears. You can then rotate the head at any angle. It may help to define the planes of the face if you draw a curved line from the top of the head (the circle or sphere) to the chin, and a curving line from the front of the ear (the side of the smaller oval) to the jaw.

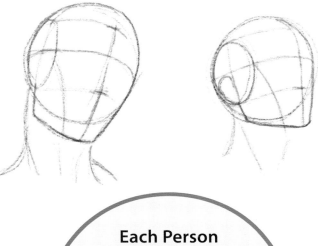

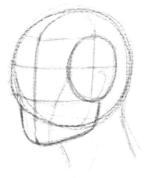

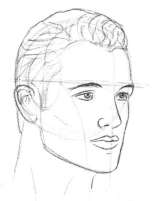

Each Person Is Unique

All the proportions given here are rough parameters. Every person has different shapes, dimensions, and proportions. These are general guidelines that can help make a drawing look right.

Male and Female Heads

These rough measurements and tips work for both male and female heads. Having these guidelines in place, it's just a matter of adding the features and some detail!

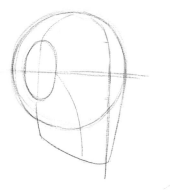

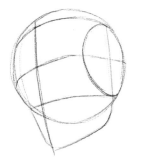

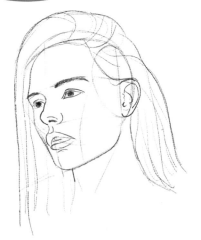

The Eye

The eyeball is a sphere inside the eye socket, though we only see a section of it.

DRAWING THE EYE

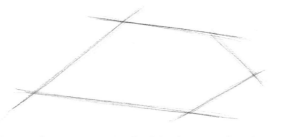

1 Begin drawing an eye by blocking in the shape with a few lines, as shown here.

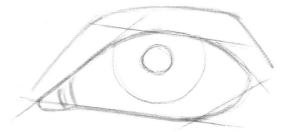

2 The lacrimal caruncle (the small nodule at the inner corner of the eye) should be slightly lower than the outer corner of the eye. The iris is a circle, and we can often see the lower part, but the upper area is usually hidden by the upper eyelid.

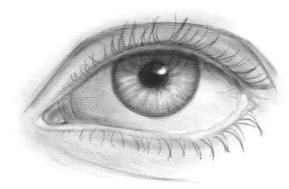

3 Finish with details.

EYE VARIATIONS

Here are eyes in different positions. In profile, the eye is drawn based on a triangular shape.

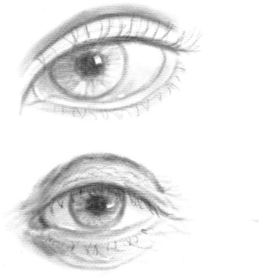

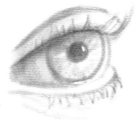

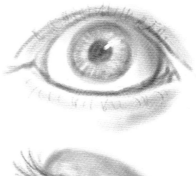

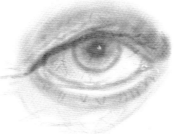

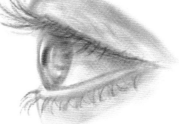

The Nose

Noses can differ greatly in size and shape from person to person. The tip may be fairly round or more squared. The noses (and the ears) of older people tend to be longer than those of young ones.

NOSE STRUCTURE
Under the skin, the upper part is bone, while the rest is cartilage.

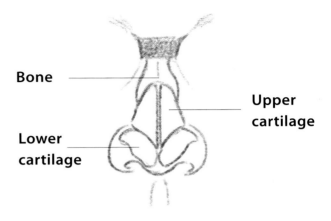

Bone

Upper cartilage

Lower cartilage

NOSE SHAPE FROM THE FRONT
The nose has a trapezoid-like shape.

NOSE SHAPE IN PROFILE
In profile, the nose is basically triangular, though it may vary.

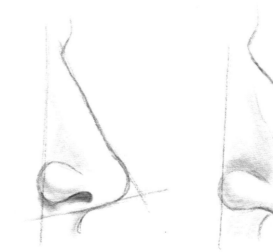

The Mouth

A common error that beginners make is to draw the mouth as if it were on a flat surface. Remember that it is covering the bone structure of the skull, which is a rounded plane holding the teeth.

MUSCLES OF THE LIPS

The upper lip has three muscles, while the lower one has two, which produces a different overall shape for each.

MOUTH VARIATIONS

*Here are mouths in different positions. In profile
(similar to eye), the mouth makes a triangular shape.*

The Ears

To draw the ear, block out its basic shape, which may be wider or thinner depending on the angle from which it is viewed. The top image here is a tilted rectangle, and the others are also four-sided shapes.

The Hair

When drawing hair, don't try to draw every single strand. Concentrate on the masses of hair and overall volume of these masses. Once that is established, you can draw individual strands to give a realistic effect if you want. When shading, make your strokes in the direction the hair flows.

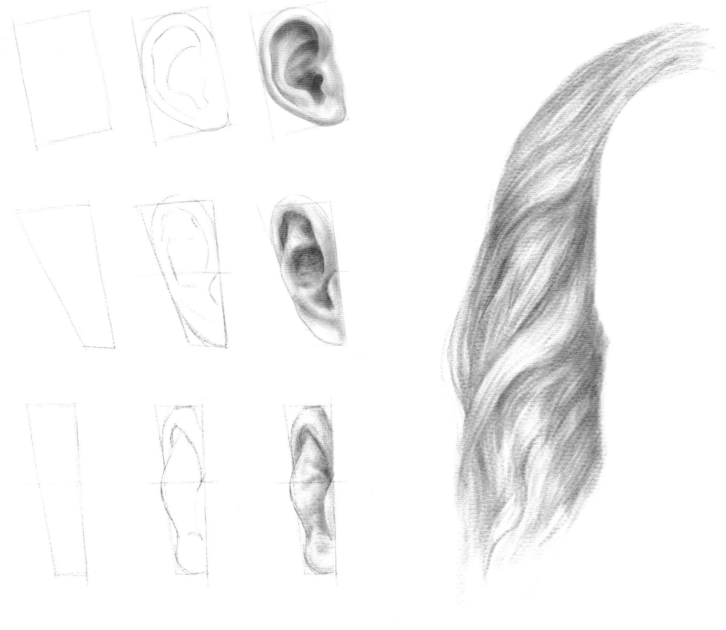

The Human Body

Artists have studied human proportions for more than two thousand years. The height of the head is taken as a unit of measurement for the rest of the body, with the height of eight heads making up the height of the figure (though seven and a half is often the case). Here we use the eight-heads classical approach in which the center division is at the crotch (although in reality, the midpoint is usually a little higher).

HEAD HEIGHTS AS LANDMARKS

1. From top of head to chin

2. From chin to nipples in males; a a bit higher in females

3. From nipples to navel

4. From navel to crotch in females; in most males, it's higher

5. From crotch to roughly halfway down thighs

6. From middle of thighs, ending just below knees

7. From knees roughly halfway down shins

8. From middle of shins to bottom of feet

Males have a shoulder span of about two heads, while female shoulders are about one and a half. Male hips are about one and a half heads wide, and the female hips about two.

Balance in the Body

The body balances itself by counterbalancing its masses.

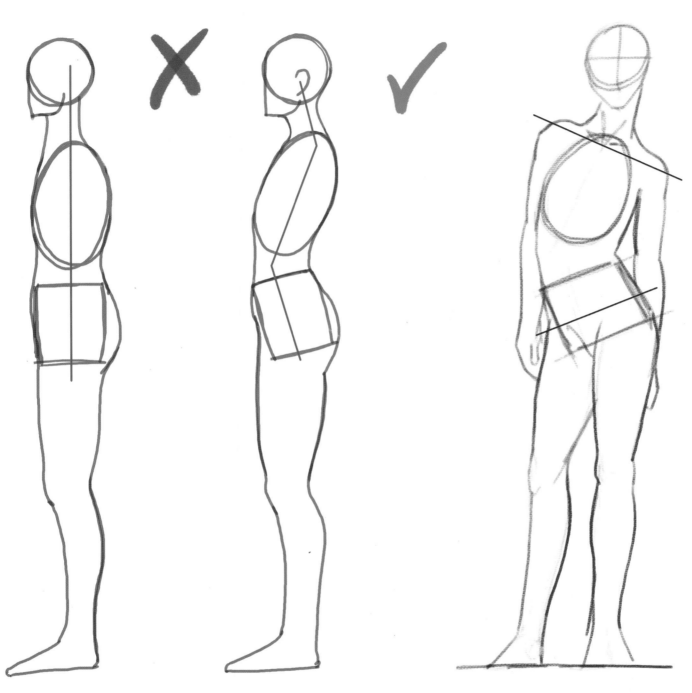

COUNTERBALANCE IN THE BODY
Viewed in profile, the body is not straight. It waves in an organic counterbalance of masses.

CONTRAPPOSTO
The hip comes up on one side because the leg holding the weight of the body is pushing it up. The shoulders counterbalance it by tilting in the opposite direction. We call a pose like this contrapposto.

OTHER LOADS AFFECT BALANCE IN THE BODY
*When someone lifts a heavy load, the body needs to compensate
and adjust to find balance.*

Edgardo Coghlan, graphite, Mexico.

The Plumb Line

To work out how weight is distributed, we can use a plumb line. Trace a line down from the center of the base of the neck to the ground, which shows the point around which the rest of the pose is supported.

SINGLE POINT OF SUPPORT
Here the plumb line runs down to one point of support, where the ballerina is balanced on her toe, with the rest of her body counterbalancing around that point.

SHARED POINT OF SUPPORT
Here the plumb line runs down to a point of support in between the ballerina's feet, which are counterbalanced around it, along with the rest of her body.

OFF-BALANCE POSE
When drawing a figure in motion, you can use an off-balance pose to show it's moving (because she could not stay still like that or she would fall).

The Hands

Hands can be difficult to draw, because they have so many parts. Simplify the hand by blocking it in as if it were a mitten, or by mark the general dimensions and overall shapes, showing the place for the finger joints. Then you can draw the fingers and give it detail in a much simpler, more effective way.

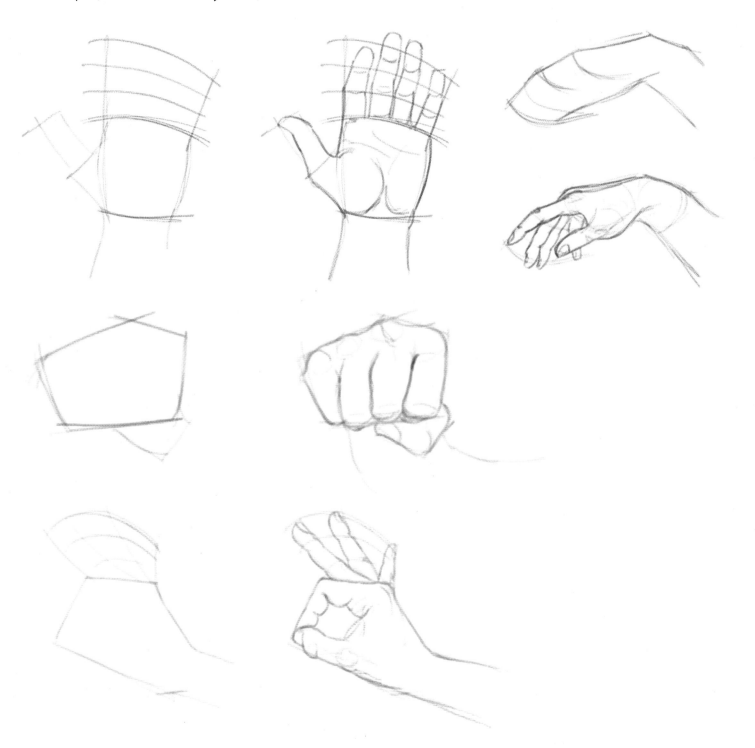

The Feet

Similarly, to draw feet, first simplify them. One way is to see the foot as a wedge with two spheres, one for the ankle joint and another, a little bit smaller, for the heel. With this technique, you can block it in fairly easily, and then add the toes and details.

To watch video tutorials related to this chapter, visit: www.fineart-tips.com/Chp11

The Artist's Survival Guide

In this chapter, you will find some tips on being an artist that you may want to explore as you continue to work on your art, including how to keep a sketchbook, how to develop your own artistic style, how to get inspiration, and how to draw from memory.

Keeping a Sketchbook

I highly recommend that you keep a sketchbook. You can keep it for yourself—you don't necessarily have to show it to others unless you want to. There are many benefits of doing so. Sketchbooks are about keeping in practice, improving your skills, capturing ideas on the fly, experimenting, just relaxing, and more. Don't underestimate the power of a sketchbook to improve your drawing and your life.

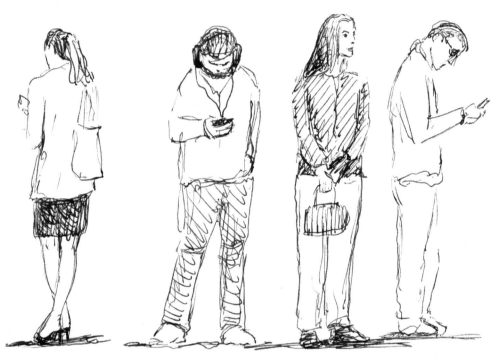

Sketching Keeps Your Hand in Practice
To be a good artist, it is essential that you draw a lot. That means daily. Bring a sketchbook everywhere with you, and sketch during any free time you have, such as on a train, in a waiting room, etc. "I draw like other people bite their nails," Pablo Picasso famously declared.

Sketching Helps You Relax
Drawing and sketching are like meditating. They can make you appreciate the present moment, which can bring you peace and make you enjoy life more. It is a way to take a break from a hectic life. You can have a great time when you draw!

Sketching Helps You Stop Worrying About Perfection
Sketching without worrying about perfection not only loosens your hand, but it can also loosen your mind. A sketchbook is a place you can feel free to make mistakes. It's the place where you test things before embarking on a larger work of art. For example, if you have a painting in mind, make sketches of different compositions and colors to use. The more sketches you make, the better the end result can be.

Sketching Helps You Develop Your Own Style

Your personal and unique style will come a whole lot faster if you routinely and regularly sketch, because drawing loosely and doing it a lot helps you develop your own way of working.

Sketching Leads to More Creativity

If you also sketch your ideas, good or bad, with no holding back, you become more creative. You can also capture your creative ideas. Thoughts come and go, and if you don't sketch them or write them down, they may be forgotten forever.

Sketching Helps You Discover New Things

It's one thing to glance at a bird. It's very different to sketch it. When you draw, you observe its shapes, size, colors, feathers, beak, toes, eyes, pose, mood, personality, etc. The same detailed observation happens when you draw a tree, a building, or anything else. Nothing makes you look at, be present with, and appreciate the world as much as drawing.

Sketching Creates a Visual Diary

If you like looking at photos and bringing back memories, you'll appreciate your sketchbooks, because you'll remember what you saw, created, imagined, and felt when you were sketching all those things.

Practical Advice

Since one key point of keeping a sketchbook is having it with you wherever you are, it should be a size you can easily carry. I use two sketchbooks, one that is about letter size that usually stays at my studio or home, as well as a tiny one that fits in my back pocket that I bring with me when I'm out. Use whatever size you can easily carry with you.

Developing Your Own Artistic Style

One of the goals of most artists is to develop their own style. This is key to standing out and therefore, to one's success. However, it often seems to be elusive. Sometimes we're told that with time, a personal style will come. And although I agree that we shouldn't worry too much about it, there are some actions that you can take to help your style find you faster.

Widen your Repertoire

Some people don't want to learn new art techniques for fear that it would influence them in such a way that they would lose their own style. And these people also resist learning different styles for the same reason. This thought is, of course, false and very limiting. It is like someone who wants to be a writer refusing to learn an extensive vocabulary for fear of losing his style. Therefore, the first thing I recommend is to master all the tools you can. By knowing and using a broad range of tools, you will be able to develop a vibrant style. And in this case, when I say tools, I mean three things.

Learn to Use Many Tools

Try working with a regular wood drawing pencil, with a mechanical pencil, and with lead holders (using leads of different sizes and hardness). Draw with vine charcoal, charcoal sticks, pencils, sanguine, colored pencils, pen and ink, etc. And the same for painting. That way, you have a full arsenal of tools you can use (although this is an endless process—just stay curious, keep testing things, and keep learning for life).

Learn Different Art Techniques

For example, you can try shading with hatching and crosshatching, by filling areas evenly with pencil, by doodling loosely, etc. Maybe you will find a particular technique that is perfect for you, that gives you new possibilities to draw or paint better. You will make it yours, and it may become an essential part of your style. And this would have never happened if you hadn't tested it in the first place.

Learn Various Styles

Similarly, learn to draw and paint in different styles, such as realism, hyperrealism, impressionism, expressionism (and other "isms"), discover an Eastern style, such as Chinese or Japanese ink drawing, etc. Of course, you don't have to try techniques or styles that are not appealing to you. But learn as many as you can.

I also recommend the exercise of copying drawings or paintings of artists that you like the most. Pay particular attention to the line work, shading, composition, colors, and contrast. Here you will see, in practice, how to successfully apply the techniques that you previously learned. I recommend copying some works of both your favorite old masters and also contemporary artists. (This exercise is just for yourself; don't sell or publish these, since you don't have the rights to those images.)

Some people resist copying other artists for fear of losing their own style. But I recommend that you at least find one artist's way of doing line work that really suits you. And you may find a set of colors from another one that you may modify and make yours. And you may find a luminosity in yet another artist's work that will help you when creating your own. Your style can get richer and can develop by learning from others.

Determine What Subject You Like the Most

Dedicate yourself to what you love most. By applying your tools, techniques, and styles to your favorite subject, you may start producing art pieces that are recognizably yours. For example, your central theme may be people, animals, landscapes, cityscapes, etc.

Sketch Your Chosen Subject a Lot

There are several reasons to sketch profusely. The more you draw, the better you become at it, and the faster you'll develop your own style. And by sketching, you will be able to experiment, to freely try crazy things; some may end up being successful, and you may adopt them

in your more serious drawings. When you sketch, you can do it freely, with no holding back, no concern that it needs to look great. Sketches are just for yourself. You do not need to show them to anyone else if they totally fail! When sketching, you can express yourself and your emotions freely. Some of your sketches may be more elaborate, but also do some that are really fast, to put your ideas down quickly. This can pay off well.

Do a Series of Drawings

Do several drawings of the subject you love creating the most, with the tools and techniques that are your favorites. When you focus on a particular subject, you may develop a recognizable style faster than you think. For example, I like to draw women on horseback. If I create a series of drawings using pen and purple ink, and create a whole body of work like this, I would be recognized quickly for that way of working.

Or you could create mainly seascapes in bluish-gray tones with a lot of light in them. If you make a series of drawings, and continue on this path, you could make it yours. This is a way to quickly jump-start your own recognizable style, all while you keep maturing, becoming more and more your own artist. So, focus and consistency are vital to finding your style.

You don't have to be limited by this, of course. You can create other subjects in different styles, but if you do a lot of work of the same kind, that will make your work recognizable. Once you have your own style, you can expand on it. Salvador Dalí created drawings, paintings, and sculptures in different techniques but when you see his work, you know it's his. It does take work, but by following this advice, your unique style may arrive faster than expected.

"Take classes learning to draw and paint and sculpt from life. Focus on the materials and expand your vocabulary on how to use them. Experiment. Don't try to come up with a style or voice or brand or idea. Lose yourself instead in curiosity for what attracts you. Play. Find flow. Look at paintings and films. Explore. What attracts others ultimately is your energy, focus, attitude, and enthusiasm, not your skill or your cleverness. Be yourself. Trust yourself."
—Alyssa Monks

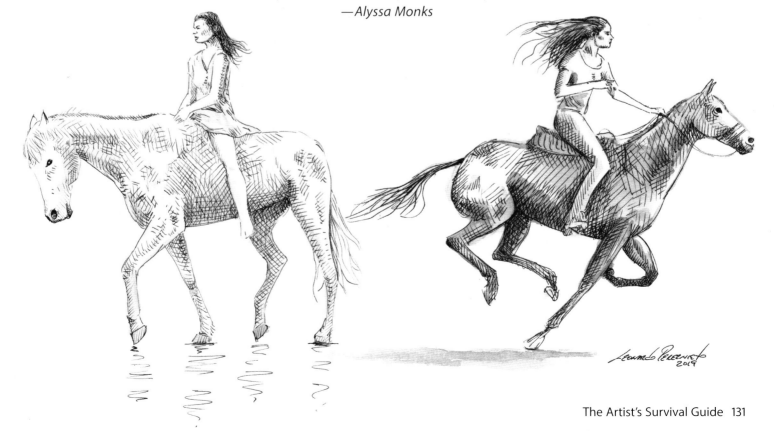

Inspiration and Overcoming Artist's Block

Inspiration is a subject that is generally thought of as difficult to teach, and it is usually not taught in art schools. However, there are some things you can do to increase inspiration. Here are what I consider the best tips for creating an explosion of ideas.

Get to Work, Even without Inspiration

It's a mistake to wait for inspiration before starting to create art, because inspiration mainly comes while you work. So, get started even if it doesn't seem to be your most meaningful work.

> "Inspiration is for amateurs. The rest of us just show up and get to work. If you wait around for the clouds to part and a bolt of lightning to strike you in the brain, you are not going to make an awful lot of work. All the best ideas come out of the process; they come out of the work itself."
> —*Chuck Close*

Find the Time to Draw

Not making enough progress with your art? Life is full of distractions. If you never seem to have the time to create, just block out the time. Schedule a time every day to be solely dedicated to creating your art. It would be great if you could block out at least three or four hours per day for it, but if that's not possible, block out an hour or whatever time you can. If it's not feasible to block out time seven days a week, block out time for as many days as possible. Let your family and close friends know this time is blocked out for your art, and tell them not to call you or distract you. Also, turn off your phone and notifications, so you don't get sidetracked.

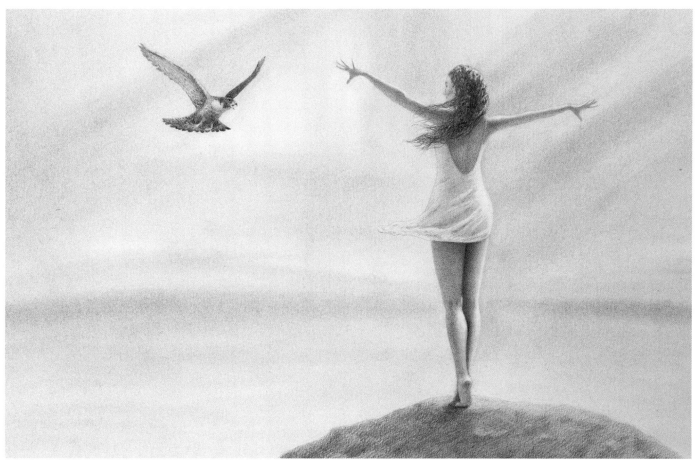

Find Your Inspiration

Make a pact with yourself that you will stick to this schedule no matter what, and do so. Preferably, make it first thing in the morning, because the more you get into other things during the day, the more difficult it is to get to your art. If you set aside time first thing each day, it will be easier to follow through. Make it a habit. You'll be surprised how much progress you'll make.

Leave Something Unfinished at Day's End

The great writer Ernest Hemingway wrote the following advice to a young colleague: "I had learned already never to empty the well of my writing, but always to stop when there was still something there in the deep part of the well, and let it refill at night from the springs that fed it." Sometimes he left incomplete sentences at night, to pick them back up in the morning, so his inspiration would keep flowing. You can leave an unfinished idea or concept for tomorrow, or ask yourself a question, and then disconnect, so that your mind continues working on it while you sleep.

Indulge in What You Love the Most

Drawing what you like the most usually comes much more spontaneously than trying to come up with something for a subject you don't like as much. It's like talking about your favorite things—it just flows.

Have a Positive Purpose

Ernest Hemingway also wrote that an individual can't just dwell on individual transformation, but also needs to confront the transformation of society to help focus on what you want to do and where you want to go. If you don't have a purpose, it's harder to be inspired, but if you have a message to share, it's easier. What matters to you? How can you represent it in an image? Think about global or social challenges, ways to raise awareness. For example, to show climate change, a photographer once published a now-famous picture of a polar bear on a tiny melting iceberg. Of course, your message can also be positive, depicting the beauty of the world, nature's harmony, friendship, love, etc.

See with the Eyes of an Artist

Discover beauty. Artists look at the world differently. If a bird flies by, an average person hardly notices. An artist observes it, trying to freeze the image in his mind to capture it in his sketchbook. Someone may see a landscape, and think it's pleasant. An artist is interested in how the tones of the hills change from closer to farther away, becoming more bluish and blurry. He sees where the light source is and even thinks of ways in which he could reorganize some elements in the scene to have a more balanced composition.

The Peace Guardian

The artist observes details and amazes himself while watching droplets on a single blade of grass. He sees its reflections and draws them. A person may walk by a bicycle-parking area without even noticing it. An artist stops, kneels, and takes a picture that shows a dance of light and shadows, creating a unique image that could well become a painting. Inspiration can arrive from any scene that most people might call mundane.

Let Inspiration Flow in Moments of Relaxation

Everyone's different, but for me, the best moments of inspiration are when I'm relaxed, such as when I'm in bed about to fall asleep, or the moments when I'm waking up, while I still don't have full awareness. That's a good time to think about new ideas. I recommend keeping your sketchbook by your bed, to capture ideas that come to you when you're waking up, or in the middle of the night. And if you're feeling stuck during the day, just get out, relax, and watch the clouds. Let them show you their shapes as a source of ideas.

Travel and Live Life

The world is full of inspiration and possibilities to discover, but only if you experience them. Seeing new cultures opens your mind. Traveling lets you observe beautiful views and things you could never have imagined otherwise, and that can fuel your inspiration.

Experience the Culture Around You

In addition to travel, read novels, poetry, visit art museums, and look at the work of artists you admire. If you are religious, reread the scriptures trying to visualize the concepts as if you were to going to paint them. Read passages of Greek mythology (they are very picturesque and inspiring) to learn about the use of symbols in art. When you have knowledge of the significance of different symbols, you can communicate through your art in new ways. Listen to good music.

Don't do any of the above passively like a spectator, but rather ask yourself how you could capture a poem that moved you, or a musical piece that gave you chills, in a drawing or painting. And when looking at the work of a master artist, ask yourself how he or she achieved it. Look at every detail of the technique, including the strokes. Find things that you didn't know before.

Learn New Drawing and Painting Techniques

You've heard this before, but again, having more tools available to you can inspire you to create works of art differently. The more techniques you master, the more room for inspiration and freedom you'll have.

Keep Your Mind Clear and Healthy

My personal advice, don't drink alcohol in excess or use harmful drugs (whether they're legal or illegal).

Get proper nutrition, and exercise routinely. Your mind is your most precious weapon when it comes to inspiration and creativity. Keep your mind and body in the best shape possible. It's been proven that consuming legal or illegal drugs decreases your intelligence over time, which is not conducive to creativity, especially in the long run. It has also been proven that when you exercise, your brain gets more oxygen, which helps you think well. If you don't enjoy going to the gym, take walks. Try alternating fast and slow walking. It's not unusual to get good ideas while walking, or even shortly after exercising.

"Inspiration exists, but it has to find you working."
—*Pablo Picasso*

Express Your Feelings
Your feelings can be a source of inspiration. If you feel sad, it's natural to draw an unhappy picture. Art is fundamentally a form of communication, and expressing what you feel is basic (and therapeutic). Express your feelings, but don't get stuck in them.

Use a Sketchbook
Again, using a sketchbook anywhere you go allows you to freely draw what you see or imagine, even if it's just doodling. If you make it a habit, your imagination and inspiration will continue to increase. And if you draw sketches or simply take notes of all the ideas that

come to your mind, your own sketchbook will become a precious source of inspiration for those times when you may get into a mental block.

Be Consistent
Do at least one sketch every day. Make creativity a habit. Do not hold back. It doesn't matter if you draw well or not, it doesn't matter if it is a good idea or not, just create. Let thoughts and inspiration flow.

Save Inspiring Images
Keep reference photos you love on your computer, perhaps organized by subject. For example, I have albums for paintings, drawings, sculpture, and landscapes. I used to have one for animals, but it got so big that I divided it into big cats, dogs, birds, etc.

Pinterest is an excellent tool for this. You can open a free account (if you don't have one yet) and create "Boards" by subject where you "Pin" the photos that inspire you from the internet.

Instagram is another recommended resource that creators use. You can follow the artists, museums, and art groups that you like the most, and every time you come to the site, you'll see the latest creations they've posted. It is an excellent source of inspiration, and you can share your work as well.

Note: Do not copy the photos or artworks of someone else, unless you have the legal right to do so, or you have written permission. Just use the images to help you get new ideas. You can develop your own work based on subjects that you like, or you can use elements in your own original art.

Glossary

Accent: The dark area created where an object touches a surface (or another object) and light is blocked. This is the darkest spot of the cast shadow.

Acid-Free Paper: Paper with a neutral pH (which therefore lasts longer and will not become yellow).

Action: The direction of the movement of a model.

Aesthetic: The theory or set of principles related to the notion of beauty.

Angles: The difference in direction or tilt between two lines or planes.

Artists' Quality: Paints that are of a higher grade, with more pigment than student quality, so the colors are more intense, and they last longer.

Atmospheric Perspective: Effect of the atmosphere on the perception of objects at different distances, making them appear to recede into the background by diminishing in value, color, and contrast. The farther away an object is from the viewer, the more it will seem to fade, the tones will lighten, and the colors will become cooler or bluer.

Axis Lines: Imaginary lines on which an object "rotates," or that divide it in half.

Balance: 1. Distribution of perceived visual weight—that is, the equalizing of visual elements in a work of art. 2. An equal distribution of weight; the state of being in equilibrium.

Binder: A substance that holds pigment particles together in drawing and painting materials.

B Leads: Pencil leads labeled with a B are soft (B stands for black). A number in front of the B (for example, 6B) indicates increasing blackness.

Blending: The technique of shading values into each other gradually.

Blocking In: To sketch the rough outline of a subject, with little or no detail, or to lay in a large area of color.

Burnishing: To layer and blend colored pencils until no paper texture is visible.

Carbon Pencils: Pencils made from a combination of compressed charcoal and graphite powder. The line produced is smooth, velvety, and matte black.

Cast Shadow: A shadow projected onto a surface by an object blocking the light.

Chalk: A soft drawing material that may be colored with natural earth pigments (blacks, whites, and browns), or other colored pigments.

Chamois: A small piece of leather for blending or for pulling out light areas in drawings.

Charcoal: A black drawing material obtained by burning twigs of willow, vine, or other woods. It is one of the oldest drawing materials.

Chroma: A color's brightness and intensity. For example, a brand new red shirt has a higher chroma than a worn-out one of the same color. *See also: saturation.*

Cold Press: Medium-textured paper that is in between hot press (finely textured) and rough. The name comes from the process used to manufacture it, in which wood pulp is pressed through metal rollers covered with felt, at a cold temperature.

Color: An object's appearance as a result of how it reflects light. Blue and red are colors.

Color Wheel: A tool used to show the interrelationships of colors. Primary, secondary, and tertiary colors are arranged in the sequence they appear in the rainbow. *See also: primary colors, secondary colors, tertiary colors, complementary colors.*

Complementary Colors: Two colors opposite one another on the color wheel that neutralize each other when mixed, but that also contrast with each other when used close together.

Composition: Arrangement of elements in an artwork used to produce an aesthetic result, such as attraction, beauty, or emotion.

Conté Crayons: Drawing sticks that come in degrees of hardness, usually in black, white, and earth colors.

Contour Lines: Lines that define the outline and volume of an object, drawn as if sliding the tip of the pencil on the actual surface of the object.

Contrast: The juxtaposition of opposite qualities in a work of art, such as the contrast of light and dark, complementary colors, rough vs. smooth, straight vs. curved, etc.

Cool Colors: These colors are calming and soothing. They recede in a drawing (they are not overpowering). They are called "cool" because they can be used to represent ice and other cool things. Blues, greens, and violets are cool colors.

Core Shadow: The darkest area of a form shadow (the shadow that falls on the planes of an object that are turned away from the light source) located a step beyond the shadow line (where a shadow transitions from lighter to darker). It's where the surface turns away from the light source and has the least light. It may be thin or wide, it can be evident, or may not show at all in a drawing. *See also*: *form shadow*.

Crosshatching: Shading by using two layers of parallel lines drawn at nearly right angles to each other.

Depth: The perception of distance, or how far an object is from the viewer.

Doodle: A pattern or an image made by loosely moving the pencil, for example, scribbling.

Dry Pastels: Chalk-like drawing sticks that come in both soft and hard types, as well as a wide range of colors. Soft pastels are made with a high concentration of pigment with a little binder to hold them together; therefore, their marks are more vivid than hard pastels. They are fragile and crumble easily. Hard pastels have more binder in them, and are used by artists for sketching and more detailed work.

Edge: The boundary that divides one shape or element from another. This transition can be sharp and sudden, gradual and soft, or anything in between. There are many ways edges can appear, but they are categorized into four types: hard, firm, soft, and lost.

Envelope: A technique to begin a drawing by looking at your subject and visualizing the rough outline, as if you had to enclose its shape just with a few lines. It is also called "blocking in." *See also: blocking in.*

Eraser: A tool used to rub out a drawing medium, often made of rubber.

Eye Level: The position of a viewer's eyes, from where a subject is seen. The eye level, or viewpoint, determines placement of a horizon line in linear perspective. *See also: linear perspective.*

Figure: The human body and its shape.

Firm Edges: A step softer than hard edges, firm edges create a visual transition between an object and what is next to it, even if that transition is small. *See also: edge, hard edges.*

Fixative: A spray substance applied to seal a drawing, so the materials don't rub off.

F Leads: Pencil leads with a hardness between H and HB leads. "F" stands for firm, since these leads are relatively hard.

Focal Point: The area or object within a composition that draws the viewer's attention and becomes the center of interest. *See also: composition.*

Form: The shape of an object or element in a composition, usually shown by its outline and/or changes in value.

Form Shadow: The shadow on the planes of an object itself that are turned away from the light source and therefore get no direct light.

Freehand: Drawing without the use of aids such as rulers, straightedges, compasses, projectors, etc.

Gesture: The lifeline, or energy, in a drawing that connects its parts.

Gesture Drawing: Done quickly, in a limited amount of time, gesture drawing captures the life, action, and expression of a subject.

Graphite: A drawing material made of carbon held together with a binder for different degrees of hardness. It leaves a metallic gray mark when rubbed on a surface, especially in its harder forms.

Guideline: A light line, usually made during an early sketch as a reference.

Half-Tones: The values in light areas on an object (as opposed to shadow areas), except for the highlight (also called mid-tones). *See also: highlight.*

Hard Edges: These are sharp, sudden changes between one area or element and the next, with no gradual transition. Hard edges draw attention, especially when accompanied by high contrast.

Hatching: A shading technique of using closely spaced parallel lines. *See also: crosshatching.*

HB Leads: Hard black leads that fall between hard and soft leads. In general, they are the equivalent of the standard American #2 pencil.

Highlight: The brightest reflection on an object.

H Leads: Leads labeled H are hard. The number in front of the H (i.e., 3H) indicates increasing hardness.

Horizon Line: The visual line where sky meets land or water, usually at the eye level of the viewer.

Hot Press: Fine-grain paper with a smooth surface. The name comes from the process used to manufacture the paper, in which wood pulp is pressed through heated metal rollers.

Hue: 1. What we usually call a color. Each of the different colors of the rainbow is a hue (red, orange, yellow, green, blue, and violet). 2. In color theory, hue refers to a pure color, without the addition of shade (added black) or tint (added white).

Inks: Liquid-based drawing materials that can be water based or shellac (resin) based. Shellac-based inks are waterproof and therefore suitable for painting over.

Landscape: What you see when you look at an area of land, such as trees, hills, and clouds.

Layer: To cover a surface with a drawing medium. To draw in layers is to build up the tone by giving a number of passes to the area.

Lead: The core material inside a pencil or lead holder that is used to draw with (though lead is a misnomer, since drawing materials contain no metallic lead).

Lightfast: The permanence or durability of a color or drawing material exposed to light.

Light Source: Where the light that illuminates an object is coming from.

Line: The most fundamental element of drawing, a line starts with a point, and then moves through space

> "A line is a dot that went for a walk."
> -Paul Klee, 1879-1940

on the surface of a drawing. Lines are often what a drawing starts with, but they can take many forms, directions, widths, etc.

Linear Perspective: The use of a horizon line, vanishing points, and converging lines to create the illusion of space in a drawing. For example, parallel lines (like two sides of a road) appear to converge at a vanishing point on the horizon. Likewise, objects appear smaller and smaller as their distance from the viewer increases.

Line of Action: *See mood line.*

Lost Edges: Borders between areas so smoothly gradated they can't be easily seen (if at all). They usually occur when adjacent objects with soft edges have the same or close values. They visually merge together, losing the boundary between them. *See also: soft edges, value.*

Mass: A large area that has been simplified in a sketch or drawing.

Mid-Tones: The values in light areas on an object (as opposed to shadow areas), except for the highlight (also called half-tones). *See also: highlight.*

Monochromatic: Drawings or paintings made with shades of only one color.

Mood Line: The main line representing the primary action in a drawing, which sets the mood. With the human figure, it usually goes from the center of the base of the neck, runs through the torso and hips, and flows through one leg. Or, the mood line may be the longest line that connects most parts of a drawing.

Negative Space: Shapes created by the space around, outside of, and in between the main shapes (positive elements) of a subject in a composition.

Nib: The pointed end of a pen, usually made of metal, which lays the ink on the paper.

Oil Pastels: Cylindrical sticks of pigment bound with an oil (or wax) medium that feel more like a crayon than other drawing materials.

One-Point Perspective: The most basic form of linear perspective using one vanishing point when the subject has one plane facing the viewer. *See also: linear perspective.*

Parallel Lines: Lines on the same plane that don't intersect. In linear perspective, parallel lines converge at vanishing points. *See also: linear perspective.*

Pastels: Drawing sticks that come in a wide range of colors. *See also: dry pastels, oil pastels.*

Pattern: A repeating element (line, shape, form, etc.) in a composition.

Pen and Ink: Drawing materials and technique where ink is applied to paper with a tool such as a dip pen, fountain pen, marker, or brush.

Pencil: A drawing instrument in which a core (such as a graphite or charcoal lead) is enclosed in a long piece of wood, usually with only one end exposed. Types of pencils vary widely.

Perspective: In art, perspective gives objects on a flat surface the illusion of three-dimensional space. Types of perspective are linear perspective, which involves the use of a horizon line, vanishing points, and converging lines to draw objects appearing smaller and smaller as their distance from the viewer increases; and atmospheric (or aerial) perspective, which has to do with variations of value, color, contrast, and detail as objects are more distant. Both are used to obtain the appearance of depth. *See also: atmospheric perspective, linear perspective.*

Pigment: Particles of solid, colored elements that are essential components of drawing materials such as pencils and inks, and give them their colors.

Plane: A flat surface, either physically existing or imagined in space.

Plumb Line: A vertical reference line.

Primary Colors: The three colors with which all other colors can be created by mixing them together, but that can't be made by mixing other colors. In fine art, they are blue, red, and yellow. The combination of two primary colors forms a secondary color. *See also: secondary colors.*

Reference Photograph: A picture used as a guide to make a drawing.

Reflected Light: Light that bounces back on an object from a surface (such as what it sits on), thus lightening its shadow.

Reflection: When light bounces off a surface, usually creating a highlight. *See also: highlight.*

Reverse Gradation: When a subject is lit from one side, while the background is lit from the opposite side (so that the lighter part of the main subject is against a dark background and the darker part is against a light background).

Rich: Abundant in something, such as pigment.

Rhythm: A principle of art that suggests harmonious movement or relationships of elements in a drawing, usually achieved through repetition of lines, shapes, colors, etc.

Sanguine: A red-brown chalk made from an earth pigment usually mined in Italy. It can be used for drawing in its natural stick form like the old masters did, but today it is more readily available through crayons or pencils. The term *sanguine* comes from the Latin word for blood, because of its reddish color.

Saturation: The intensity of a color. Highly saturated colors are vivid, while unsaturated colors are dull and tending toward gray. *See also: chroma.*

Scale: The size of an object.

Secondary Colors: The three colors made by combining two primary colors. Green is made by mixing blue and yellow. Orange is made by mixing red and yellow. Violet is made by mixing blue and red.

Sepia: A dark brown color that is used mainly for monochromatic drawings. The sepia solution was initially obtained from the ink of sea animals, such as squid. Today, it's readily available in stick and pencil forms. This color became famous all the way back in the Renaissance, and it is still a favorite of artists, although today it is produced synthetically.

Shade: 1. A color to which black has been added. *See also: tint.* 2. A dark value, or an area not in the light.

Shading: To darken an area in a drawing, usually to represent shadow.

Shadow: An area receiving no direct light. The two main types of shadows are the form shadow and the cast shadow. The form shadow is on the planes of the object itself that are turned away from the light source, and therefore get no direct light. The cast shadow is projected by an object blocking the light from hitting another surface, such as a surface below or behind it. *See also: cast shadow, form shadow.*

Shadow Line: Also called the terminator, the shadow line is the border where a transition from light to shadow occurs on a shape. It's where the light source stops directly hitting the surface, that is, just before the plane begins to face away from the light.

Shape: A flat, enclosed, two-dimensional area, usually bound by lines, values, or colors.

Sight Size: The measurement of a distant object as the artist sees it, in order to draw it at that relative size on the paper.

Sketch: A rough, rapid drawing without much detail that is used to practice techniques or as reference for a later, more detailed work. Sketches can also have artistic value as brief creative pieces themselves.

Smudge: To blur or soften a medium, such as charcoal, by rubbing with a soft tool.

Soft Edges: Smooth transitions or gradations between two areas in a drawing.

Soften: To make something (such as a line, a color, etc.) less evident, either by lightly erasing it or by applying an even layer of drawing material on it.

Still Life: A drawing of non-moving, inanimate objects, such as fruits or bottles.

Stippling: To draw by using small dots.

Structure: The solid foundation that holds something in place, such as basic three-dimensional forms (cubes, spheres, cylinders, etc.). In the human body, it includes the rib cage, shoulder bones, arms, etc.

Stump: A blending tool for graphite, charcoal, and pastel. It is a cylinder tapered at both ends, made out of tightly wound, soft paper.

Support: Any material on which an artist can draw or paint, such as paper, wood, or canvas.

Surface: 1. The uppermost layer of an object that determines how light (or color) is reflected, absorbed, or scattered. A surface has its own texture and color. 2. The material upon which an artwork is made (paper, canvas, wood, panel, etc.).

Technique: A method of performing an activity, often requiring practical skills.

Terminator: *See shadow line.*

Tertiary Colors: Colors produced by mixing two secondary colors, or by mixing a primary and a secondary. *See also: primary colors, secondary colors.*

Texture: How things feel or how they look like they would feel if touched.

Three-Point Perspective: A linear perspective technique that uses three vanishing points to create the illusion of space. *See also: linear perspective.*

Tint: A color to which white pigment has been added. *See also: shade.*

Tone: In art, it means the degree of lightness or darkness in a drawing. *See also: value.*

Tooth: A paper's grain or texture. The more tooth a paper has, the more it holds the drawing material, such as charcoal or graphite.

Tortillion: A tool for smudging and blending, made of rolled paper. It is slender and often used for details.

Two-Point Perspective: A type of linear perspective using two separate vanishing points on the horizon line where parallel lines meet. *See also: linear perspective.*

Value: Darkness or lightness in a drawing or painting. White is the lightest value, and black is the darkest.

Value Scale: A system of organizing values. Though there are an unlimited number of values, artists often use a scale of 1 to 10, often with black being 1 and white being 10.

Vanishing Point: In linear perspective, a vanishing point is where parallel lines appear to converge on the horizon line. *See also: linear perspective.*

Volume: 1. The three-dimensional qualities of objects, such as height, width, and depth. 2. The illusion of three dimensions in a two-dimensional image.

V.P.: Vanishing point.

Warm Colors: Reds, oranges, and yellows. They are called warm because they can be used to represent fire. They tend to pull the attention of the viewer.

• •

Bibliography

I recommend the following valuable resources.

Books

George B. Bridgman
Bridgman's Complete Guide to Drawing from Life

Ken Hultgren
The Art of Animal Drawing

Steve Huston
Figure Drawing for Artists

Andrew Loomis
Drawing the Head and Hands
Figure Drawing for All It's Worth

Mike Mattesi
Drawing Force

Kimon Nicolaïdes
The Natural Way to Draw: A Working Plan for Art Study

Jake Spicer
Life Drawing in 15 Minutes

Ron Tiner
Figure Drawing Without a Model

Mark and Mary Willenbrink
Drawing for the Absolute Beginner

Samantha Youssef
Movement and Form: The Youssef Drawing Syllabus

YouTube Channels

Alphonso Dunn
Fine Art-Tips
Love Life Drawing
Proko

Sketches on pages 27 and 131 inspired by @zintapolo, @nantucket and @chloecarabasi.

Final Thoughts

Drawing may be your dream. Or maybe you just want to draw for relaxation, to enjoy yourself. Either way, this book has given you the fundamentals to build on. Like anything worthwhile, your results won't be immediate. But what is essential is that you enjoy the process. Understand that you are in for the long haul and that by making small steps forward, little improvements today, tomorrow, and next year, and by having a strong foundation, you will be able to achieve your ambitions and your dreams.

Make a commitment to draw for at least fifteen minutes every day. Soon it will become a habit, and you will find your drawing sessions extending longer. Drawing is about doing it, so focus on that. May this be the beginning of an adventure that takes you to new horizons. And by embarking on this adventure, you will make a more beautiful world for yourself and for others as well.

Acknowledgments

Thank you for your interest, for keeping the artistic tradition alive, and for wanting to make a better world.

I appreciate all the love my wife Gabriela gave me during the process of making this work.

I'm grateful to Carrie Kilmer and her SoHo Publishing team for their continuing support and their patience on this project.

Dedication

To Gaby, Luna, and Corazón. My three loves.

Index